Art Studio

Flowers

More than 50 projects and techniques for drawing, painting, and creating your favorite flowers and botanicals in oil, acrylic, pencil, and more!

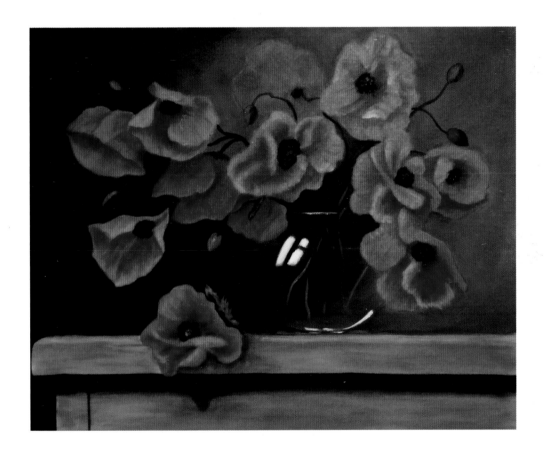

Brimming with creative inspiration, how-to projects, and useful information to enrich your everyday life, Quarto Knows is a favorite destination for those pursuing their interests and passions. Visit our site and dig deeper with our books into your area of interest: Quarto Creates, Quarto Cooks, Quarto Homes, Quarto Lives, Quarto Drives, Quarto Explores, Quarto Gifts, or Quarto Kids.

First Published in 2017 by Walter Foster Publishing, an imprint of The Quarto Group.
6 Orchard Road, Suite 100, Lake Forest, CA 92630, USA.
T (949) 380-7510 F (949) 380-7575 www.QuartoKnows.com

Walter Foster Publishing titles are also available at discount for retail, wholesale, promotional, and bulk purchase. For details, contact the Special Sales Manager by email at specialsales@quarto.com or by mail at The Quarto Group, Attn: Special Sales Manager, 401 Second Avenue North, Suite 310, Minneapolis, MN 55401 USA.

ISBN: 978-1-63322-363-9

Cover design by Eoghan O' Brien
Page layout by Ashley Prine, Tandem Books

Printed in China
10 9 8 7 6 5 4 3 2 1

TABLE OF CONTENTS

Drawing

DRAWING PAPER Drawing paper is available in a range of surface textures (called "tooth"), including smooth grain (plate finish and hot pressed), medium grain (cold pressed), and rough to very rough. Cold-pressed paper is the most versatile and is great for a variety of drawing techniques. For finished works of art, using single sheets of drawing paper is best.

SKETCH PADS Sketch pads come in many shapes and sizes. Although most are not designed for finished artwork, they are useful for working out your ideas.

ERASERS There are several types of art erasers. Plastic erasers are useful for removing hard pencil marks and large areas. Kneaded erasers (a must) can be molded into different shapes and used to dab at an area, gently lifting tone from the paper.

TORTILLONS These paper "stumps" can be used to blend and soften small areas when your finger or a cloth is too large. You also can use the sides to blend large areas quickly. Once the tortillons become dirty, simply rub them on a cloth, and they're ready to go again.

DRAWING IMPLEMENTS

Drawing pencils, the most common drawing tool and the focus of this book, contain a graphite center. They are categorized by hardness, or grade, from very soft (9B) to very hard (9H). A good starter set includes a 6B, 4B, 2B, HB, B, 2H, 4H, and 6H. The chart below shows a variety of drawing tools and the kinds of strokes you can achieve with each one.

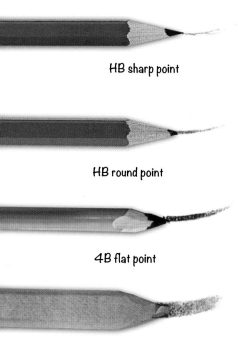

HB sharp point

HB round point

4B flat point

Flat sketching

HB An HB with a sharp point produces crisp lines and offers good control. A round point produces slightly thicker lines and is useful for shading small areas.

FLAT For wider strokes, use a 4B with a flat point. A large, flat sketch pencil is great for shading bigger areas.

CHARCOAL 4B charcoal is soft and produces dark marks. Natural charcoal vines are even softer and leave a more crumbly residue on the paper. White charcoal pencils are useful for blending and lightening areas.

CONTÉ CRAYON OR PENCIL Conté crayon is made from very fine Kaolin clay and is available in a wide range of colors. Because it's water soluble, it can be blended with a wet brush or cloth.

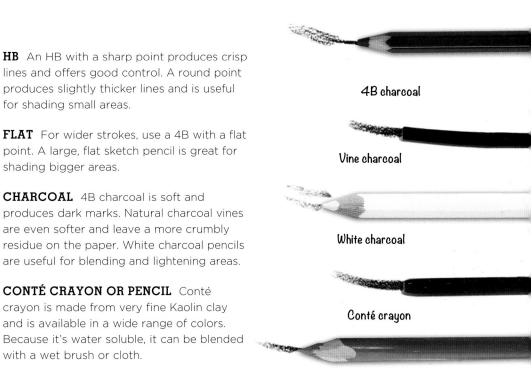

4B charcoal

Vine charcoal

White charcoal

Conté crayon

Conté pencil

SHARPENING YOUR PENCILS

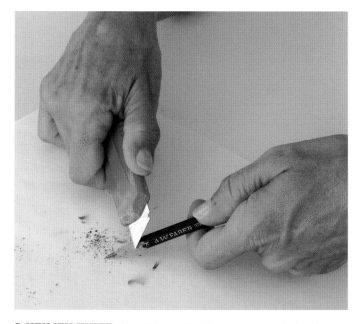

A UTILITY KNIFE Use this tool to form a variety of points (chiseled, blunt, or flat). Hold the knife at a slight angle to the pencil shaft, and always sharpen away from you, taking off a little wood and graphite at a time.

A SANDPAPER BLOCK This tool will quickly hone the lead into any shape you wish. The finer the grit of the paper, the more controllable the point. Roll the pencil in your fingers when sharpening to keep its shape even.

Oil & Acrylic

PAINTS

Paint varies in expense by grade and brand, but even reasonably priced paints offer sufficient quality. Very inexpensive paints might lack consistency and affect your results, but buying the most costly color may limit you. Find a happy medium.

PALETTE & PAINTING KNIVES

Palette knives are mainly used for mixing colors on your palette and come in various sizes and shapes. Some knives can also be used for applying paint to your canvas, creating texture in your work, or even removing paint. Palette knives are slightly rounded at the tip. Painting knives are pointed and a bit thicker, with a slightly more flexible tip.

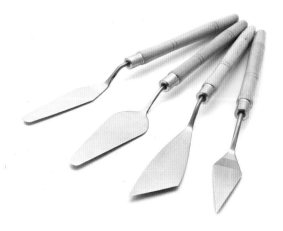

PALETTES

Palettes for acrylic range from white, plastic handheld palettes to sheets of plexiglass. The traditional mixing surface for oils is a handheld wooden palette, but many artists opt for a plexiglass or tempered glass palette. A range of welled mixing palettes are available for watercolorists, from simple white plastic varieties to porcelain dishes.

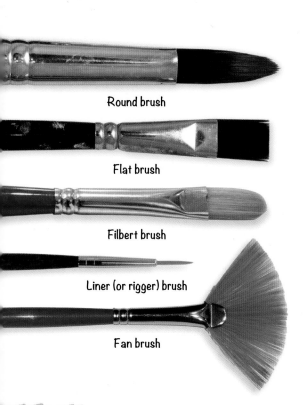

Round brush

Flat brush

Filbert brush

Liner (or rigger) brush

Fan brush

BRUSHES

Synthetic brushes are the best choice for acrylic painting because their strong filaments can withstand the caustic nature of acrylic. Sable and soft-hair synthetic brushes are ideal for watercolor. A selection of hog bristle brushes is a staple for all oil painters. Build your starter set with small, medium, and large flat brushes; a few medium round brushes; a liner (or rigger) brush; a medium filbert brush; and a medium fan brush. Brushes are commonly sized with numbers, although the exact sizes vary between manufacturers. Generally #1 to #5 are small brushes, #6 to #10 are medium brushes, and #11 and up are large brushes. Flat brushes are often sized by the width of the ferrule (or brush base), such as ¼-inch, ½-inch, and 1-inch flat brushes.

PAINTING SURFACES

Although you can paint with oils and acrylics on almost any material, from watercolor paper to wooden board, canvas is the most popular choice. Watercolor paper is the perfect surface for the fluid washes of watercolors. Many artists like using this durable paper for other wet and dry media.

MEDIUMS, SOLVENTS & ADDITIVES

Drying oils and oil mediums allow artists to change the consistency and reflective qualities of oil paint. Although you can technically paint straight from the tube, most artists add medium to extend the paint and to build an oil painting in the traditional "fat over lean" layering process. Because oil-based paints do not mix with water, artists traditionally use solvents, such as odorless mineral spirits, for paint thinning and cleanup. If you choose to purchase a solvent, be sure it is intended for fine-art purposes. Note any instructions and cautions provided by the manufacturer.

To thin and clean up acrylic and watercolor, water is the simplest medium. However, you can also find mediums and additives made specifically for these types of paint. A range of gels, pastes, and additives allow artists alter to the behavior and properties of acrylic paint, such as extending the drying time or creating a coarse texture. Watercolor mediums are less common, but some artists rely on adding ox gall, gum arabic, granulation medium, or iridescent medium to create specific effects.

ADDITIONAL SUPPLIES

Some additional supplies you'll want to have on hand include:

- Paper, pencils, and a sharpener for drawing, sketching, and tracing
- Jars of water, paper towels, and a spray bottle of water
- Fixative to protect your initial sketches before you apply paint

Colored Pencil

Colored pencil artwork requires few supplies. Many pencil brands are sold at reasonable prices in art stores and online; however, it's best to purchase artist-grade, professional pencils whenever possible. Student-grade pencils will not produce lasting works of art because the colors tend to fade quickly.

COLORED PENCILS

There are three types of colored pencils: *wax-based*, *oil-based*, and *water-soluble*. You should purchase a few of each and test them to see what looks great on paper.

WAX-BASED Wax-based pencils are known for their creamy consistency an easy layering. However, they wear down quickly, break more frequently, and leave pencil crumbs behind. This is easily manageable with careful sharpening, gradual pressure, and the use of a drafting brush to sweep away debris. Wax bloom, a waxy buildup that surfaces after numerous layers of application, may also occur. It is easy to remove by gently swiping a soft tissue over the area.

OIL-BASED These pencils produce generous color with little breakage. There is no wax bloom and little pencil debris. They sharpen nicely and last longer than wax-based pencils. They can be harder to apply, but they are manageable when establishing color and building layers.

WATER-SOLUBLE These pencils have either wax-based or oil-based cores, which allow for a watercolor effect. Use them dry like a traditional colored pencil, or apply water to create a looser, flowing effect. This is especially nice for slightly blurred backgrounds.

CHOOSING PAPER

Smooth Bristol paper is a hot-pressed paper that accepts many layers of color. It allows you to build up your colors with a lot of layering and burnishing, which involves using strong pressure to create a polished, painterly surface. Additional surfaces include velour paper, museum board, suede mat board (great for animal fur), illustration board, wood, and sanded paper, which eats up pencils quickly but presents a beautiful, textured look. Experiment with different surface types, colors, and textures until you find what works for you.

Textured paper has defined ridges that accept many colored pencil layers without compromising the paper.

Smooth paper is less likely to accept multiple applications of color without ripping.

UNDERSTANDING PAPER TOOTH Choose paper based on the tooth, or paper texture. Rough paper contains more ridges than smooth paper. The paper's tooth will determine how many layers you can put down before the paper rips. Hot-pressed paper has less tooth and a smoother texture. Cold-pressed paper has more tooth and a rougher texture, which is excellent for water-soluble pencils.

Pastel

When selecting pastels, it is important to understand the different qualities of each type of pastel. There are three main types: soft, hard, and pastel pencils. Beginners should collect a large assortment of artist's-quality soft pastels (70 or more) and a smaller selection of hard pastels.

Sot Pastels

SOFT PASTELS Good-quality soft pastels are composed of almost pure pigment, with a very small amount of filler and just a touch of binder to hold them together. As a result, they are more sensitive and crumble easily. Soft pastels are incredibly brilliant, with beautiful covering strength. The degree of softness and shape varies depending on the brand. Traditional soft pastels are round, yet many are currently produced in a shorter square format. Thanks to the popularity of the pastel medium, there is an ever-growing selection of quality soft pastels on the market today. But as a beginner, you can explore the available pastels to find what works for you. Soft pastels are quite versatile and can be applied in thin glazes or in thick impasto painting techniques. They come in very large selections of up to 500 colors to choose from, including all the tints, shades, and tones. They can even be bought in sets designed specifically for landscape, portrait, or still life use. Soft pastels can also be purchased in single sticks.

HARD PASTELS Hard pastels are typically thinner and longer than soft pastels. They also contain more binder and less pigment. Hard pastels do not fill the tooth, or grain, of the paper as quickly as soft pastels, nor do they have quite the same tinting strength, yet they can be used interchangeably with soft pastel throughout a painting. Hard pastels can be sharpened to a point with a razor because of their harder consistency. They work well for a linear drawing approach, making them ideal for applying small details as well as laying in the preliminary drawing. Hard pastels are great for portrait details. Keep a selection of earth and skin tones on hand, as well as neutral accents like black and white.

Hard Pastels

PASTEL PENCILS Pastel pencils are essentially a hard pastel core in a protective wood covering. They are designed to be sharpened to a point and can be used either for detail work or sketching. You can buy pastel pencils in full sets or individually. It is beneficial to have a selection of pastel pencils on hand, though not necessary if you already have hard pastels.

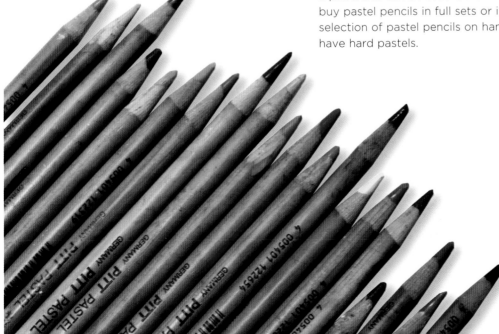

Pastel Pencils

Watercolor

The airy and atmospheric qualities of watercolor set it apart from other painting media. Watercolor is a fluid medium that requires quite a bit of practice to master; however, if you devote enough time to this medium, you'll understand why it is praised for its ability to quickly capture an essence, suggesting form and color, with just a few brushstrokes.

TYPES OF WATERCOLOR

Watercolor is pigment dispersed in a vehicle of gum arabic (a binder), glycerin (a plasticizer to prevent dry paint from cracking), corn syrup or honey (a humectant to keep the paint moist), and water. Fillers, extenders, and preservatives may also be present. Watercolor comes in four basic forms: tubes, pans, semi-moist pots, and pencils. What you choose should depend on your painting style and preferences.

TUBES

Tubes contain moist paint that is readily mixable. This format is great for studio artists who have room to store tubes and squirt out the amount needed for a painting session. Unlike oil and acrylic, you need only a small amount of tube paint to create large washes. Start with a pea-sized amount, add water, and then add more paint if necessary.

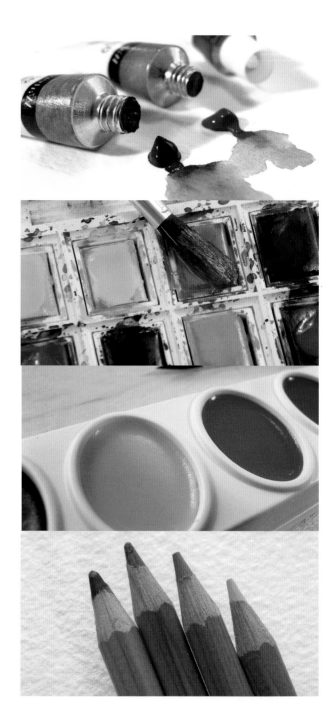

PANS

Pans, also called "cakes," are dry or semi-moist blocks of watercolor. Many lidded watercolor palettes are designed to hold pans, making them portable and convenient. They often contain more humectant than tube paints to prevent the paint from drying out. To activate the paint, stroke over the blocks with a wet brush. To create large washes or mixes, load the brush with paint and pull color into a nearby well.

SEMI-MOIST POTS

Semi-moist pots are the most economical option. The colors sit in round pots, often in a row with a lid that serves as a mixing tray. Like pans, these gummy-looking watercolors are formulated with more humectant to retain moisture. Activate the paint by stroking over the color with a wet brush.

WATERCOLOR PENCILS

These tools combine the fluid, colorful nature of watercolor with the control of pencil drawing. Available in both wood-encased and woodless forms, they feature leads of hard watercolor that you can sharpen like any graphite pencil. They are great for creating fine details or sketching a composition for traditional watercolor painting, or you can use them with a wet brush to develop entire works.

MEDIUMS

Watercolor mediums and additives alter the characteristics of the paint. Whether you want more flow, gloss, sparkle, or texture, a number of products are available to help you achieve your desired results.

GUM ARABIC Made from the sap of an acacia tree, gum arabic is the binder of watercolor paint. When added to your jar of clean mixing water, it increases the gloss and transparency of watercolor.

OX GALL Ox gall is made of alcohol and cow bile. The medium is a wetting agent that reduces the surface tension of water and increases the fluidity of watercolor. It is particularly useful when working in large washes on hard-sized watercolor paper, as it makes the paper more readily accept paint. Add just a few drops to your jar of clean mixing water to see the effects.

IRIDESCENT MEDIUM

Iridescent medium gives a metallic shimmer to watercolor paint. Mix a small amount into your washes, noting that a little bit goes a long way. For more dramatic results, stroke the medium directly over a dried wash.

LIFTING PREPARATION MEDIUM

Lifting preparation medium allows you to easily lift watercolor from your paper—even staining pigments. Apply the medium to the paper with a brush and allow it to dry; then stroke over the area with watercolor. After the paint dries, use a wet brush to disturb the wash and lift the paint away by dabbing with tissue or paper towel. These swatches show attempts to lift permanent carmine on a surface prepped without (A) and with (B) lifting preparation (see below).

MASKING FLUID

Masking fluid, also called "liquid frisket," is a drying liquid, such as latex, that preserves the white of the paper while you paint. This allows you to stroke freely without working around highlights. Fluids may be colored or colorless and rub-away or permanent.

GRANULATION MEDIUM

When used in place of water in a watercolor wash, this medium encourages granulation. It is most effective when used with nongranulating colors such as modern pigments. In these examples at left, view phthalo blue with (A) and without (B) granulation medium.

Pencil Techniques

HATCHING This basic method of shading involves filling an area with a series of parallel strokes. The closer the strokes, the darker the tone will be.

CROSSHATCHING For darker shading, place layers of parallel strokes on top of one another at varying angles. Again, make darker values by placing the strokes closer together.

SHADING DARKLY By applying heavy pressure to the pencil, you can create dark, linear areas of shading.

GRADATING To create gradated values (from dark to light), apply heavy pressure with the side of your pencil, gradually lightening the pressure as you stroke.

BLENDING To smooth out the transitions between strokes, gently rub the lines with a blending tool or tissue.

SHADING WITH TEXTURE For a mottled texture, use the side of the pencil tip to apply small, uneven strokes.

You can create an incredible variety of effects with a pencil. By using various hand positions and shading techniques, you can produce a world of different stroke shapes, lengths, widths, and weights.

Hatching

Crosshatching

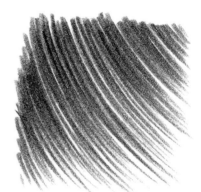

Shading Darkly

Blending

Gradating

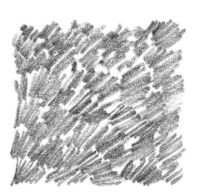

Shading with Texture

CREATING FORM

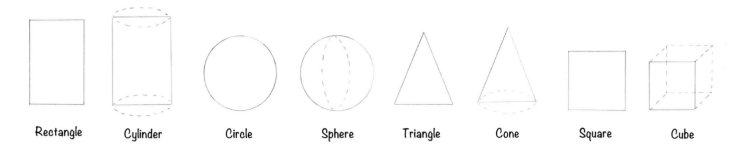

| Rectangle | Cylinder | Circle | Sphere | Triangle | Cone | Square | Cube |

The first step when creating an object is to establish a line drawing to delineate the flat area that the object takes up. This is known as the "shape" of the object.

ADDING VALUE TO CREATE FORM

A shape can be further defined by showing how light hits the object to create highlights and shadows. First note from which direction the source of light is coming. (In these examples, the light source is beaming from the upper right.)

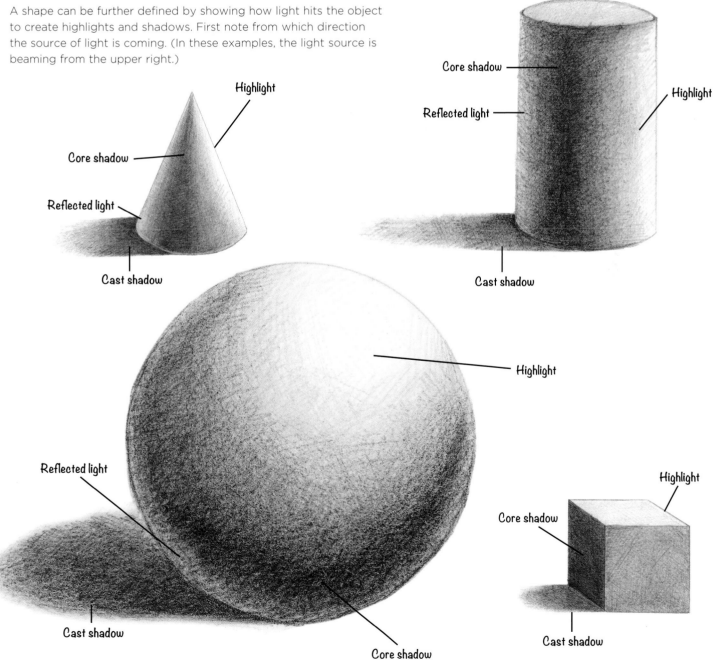

Acrylic Techniques

There are myriad techniques and tools that can be used to create a variety of textures and effects. By employing some of these different techniques, you can spice up your art and keep the painting process fresh, exciting, and fun!

FLAT WASH This thin mixture of acrylic paint has been diluted with water (use solvents to dilute oil paint). Lightly sweep overlapping, horizontal strokes across the support.

GRADED WASH Add more water or solvent and less pigment as you work your way down. Graded washes are great for creating interesting backgrounds.

DRYBRUSH Use a worn flat or fan brush loaded with thick paint, wipe it on a paper towel to remove moisture, then apply it to the surface using quick, light, irregular strokes.

STIPPLE Take a stiff brush and hold it very straight, with the bristle-side down. Then dab on the color quickly, in short, circular motions. Stipple to create the illusion of reflections.

SCUMBLE With a dry brush, lightly scrub semi-opaque color over dry paint, allowing the underlying colors to show through. This is excellent for conveying depth.

SCRAPE Using the side of a palette knife or painting knife, create grooves and indentations of various shapes and sizes in wet paint. This works well for creating rough textures.

LIFTING OUT Use a moistened brush or a tissue to press down on a support and lift colors out of a wet wash. If the wash is dry, wet the desired area and lift out with a paper towel.

IMPASTO Use a paintbrush or a painting knife to apply thick, varied strokes, creating ridges of paint. This technique can be used to punctuate highlights in a painting.

THICK ON THIN Stroking a thick application of paint over a thin wash, letting the undercolor peek through, produces textured color variances perfect for rough or worn surfaces.

MASK WITH TAPE Masking tape can be placed onto and removed from dried acrylic paint without causing damage. Don't paint too thickly on the edges—you won't get a clean lift.

DRY ON WET Create a heavily diluted wash of paint; then, before the paint has dried, dip a dry brush in a second color and stroke quickly over it to produce a grainy look.

Flat Wash

Graded Wash

Drybrush

Stipple

Scumble

Scrape

Lifting Out

Impasto

Thick on Thin

Mask with Tape

Dry on Wet

Oil Techniques

Most oil painters apply paint to their supports with brushes. The variety of effects you can achieve—depending on your brush selections and your techniques—is virtually limitless. Just keep experimenting to find out what works best for you. A few of the approaches to oil painting and brushwork techniques are outlined below.

PAINTING THICKLY Load your brush or knife with thick, opaque paint and apply it liberally to create texture.

THIN PAINT Dilute your color with thinner, and use soft, even strokes to make transparent layers.

DRYBRUSH Load a brush, wipe off excess paint, and lightly drag it over the surface to make irregular effects.

BLENDING Use a clean, dry hake or fan brush to lightly stroke over wet colors to make soft, gradual blends.

GLAZING Apply a thin layer of transparent color over existing dry color. Let dry before applying another layer.

PULLING AND DRAGGING Using pressure, pull or drag dry color over a surface to texture or accent an area.

SCUMBLING Lightly brush semi-opaque color over dry paint, allowing the underlying colors to show through.

SPONGING Apply paint with a natural sponge to create mottled textures for subjects such as rocks or foliage.

WIPING AWAY Wipe away paint with a paper towel or blot with newspaper to create subtle highlights.

SPATTER Randomly apply specks of color on your canvas by flicking thin paint off the tip of your brush.

SCRAPING Use the tip of a knife to remove wet paint from your support and reveal the underlying color.

STIPPLING Using the tip of a brush or knife, apply thick paint in irregular masses of small dots to build color.

When you're learning a new technique, it's a good idea to practice on a separate sheet first. Once you're comfortable with the technique, you can apply it with confidence to your final work.

Painting Thickly

Thin Paint

Drybrush

Blending

Glazing

Pulling and Dragging

Scumbling

Sponging

Wiping Away

Spatter

Scraping

Stippling

Colored Pencil Techniques

VARYING STROKES Experiment with the tip of your pencil as you create a variety of marks, from tapering strokes to circular scribbles.

GRADATING To create a gradation with one color, stroke side to side with heavy pressure and lighten the pressure as you move away, exposing more of the white paper beneath the color.

HATCHING & CROSSHATCHING Add shading and texture to your work with hatching (parallel lines) and crosshatching (layers of parallel lines applied at varying angles).

LAYERING You can optically mix colored pencils by layering them lightly on paper. In this example, observe how layering yellow over blue creates green.

STIPPLING Apply small dots of color to create texture or shading. The closer together the dots, the darker the stippling will "read" to the eye.

BURNISHING For a smooth, shiny effect, burnish by stroking over a layer with a colorless blender, a white colored pencil (to lighten), or another color (to shift the hue) using heavy pressure.

BLENDING To blend one color into the next, lighten the pressure of your pencil and overlap the strokes where the colors meet.

SCUMBLING Create this effect by scribbling your pencil over the surface of the paper in a random manner, creating an organic mass of color.

Varying Strokes

Gradating

Hatching & Crosshatching

Layering

Stippling

Burnishing

Blending

Scumbling

Pastel Techniques

UNBLENDED STROKES To transition from one color to another, allow your pastel strokes to overlap where they meet. Leaving them unblended creates a raw, energetic feel and maintains the rhythm of your strokes.

BLENDING To create soft blends between colors, begin by overlapping strokes where two colors meet. Then pass over the area several times, using a tissue, chamois, or stump to create soft blends.

GRADATING A gradation is a smooth transition of one tone into another. To create a gradation using one pastel, begin stroking with heavy pressure and lessen your pressure as you move away from the initial strokes.

STROKING OVER BLENDS You can create rich colors and interesting contrasts of texture by stroking over areas of blended pastel.

SCUMBLING This technique involves scribbling to create a mottled texture with curved lines. Scumble over blended pastel for extra depth.

MASKING Use artist tape to create clean edges in your drawings or to mask out areas that should remain free of pastel.

Generally used alongside with soft pastel, hard pastel is less vibrant and is best for preliminary sketches and small details. Like soft pastel, hard pastel is available in both sticks and pencils.

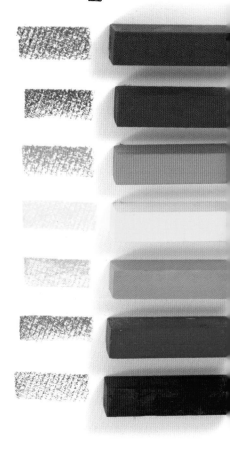

Unblended Strokes

Blending

Gradating

Stroking over Blends

Scumbling

Masking

Watercolor Techniques

Unlike other painting media, watercolor relies on the white of the paper to tint the layers of color above it. Because of this, artists lighten watercolor washes by adding water—not by adding white paint. To maintain the luminous quality of your watercolors, minimize the layers of paint you apply so the white of the paper isn't dulled by too much pigment.

GRADATED WASH A gradated (or graduated) wash moves slowly from dark and to light. Apply a strong wash of color and stroke in horizontal bands as you move away, adding water to successive strokes.

BACKRUNS Backruns, or "blooms," create interest within washes by leaving behind flower-shaped edges where a wet wash meets a damp wash. First stroke a wash onto your paper. Let the wash settle for a minute or so, and then stroke another wash within (or add a drop of pure water).

WET-INTO-WET Stroke water over your paper and allow it to soak in. Wet the surface again and wait for the paper to take on a matte sheen; then load your brush with rich color and stroke over your surface. The moisture will grab the pigments and pull them across the paper to create feathery soft blends.

TILTING To pull colors into each other, apply two washes side by side and tilt the paper while wet so one flows into the next. This creates interesting drips and irregular edges.

FLAT WASH A flat wash is a thin layer of paint applied evenly to your paper. First wet the paper, and then load your brush with a mix of watercolor and water. Stroke horizontally across the paper and move from top to bottom, overlapping the strokes as you progress.

USING SALT For a mottled texture, sprinkle salt over a wet or damp wash. The salt will absorb the wash to reveal the white of the paper in interesting starlike shapes. The finer the salt crystals, the finer the resulting texture.

DRYBRUSHING Load your brush with a strong mix of paint; then dab the hairs on a paper towel to remove excess moisture. Drag the bristles lightly over the paper so that tooth catches the paint and creates a coarse texture. The technique works best when used sparingly and with opaque pigments over transparents.

USING A SPONGE In addition to creating flat washes, sponges can help you create irregular, mottled areas of color.

SPATTERING Load your brush with a wet wash and tap the brush over a finger to fling droplets of paint onto the paper. You can also load your brush and then run the tip of a finger over the bristles to create a spray.

USING ALCOHOL To create interesting circular formations within a wash, use an eyedropper to drop alcohol into a damp wash. Change the sizes of your drops for variation.

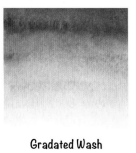

Gradated Wash

Backruns

Wet-Into-Wet

Tilting

Flat Wash

Salt

Drybrushing

Sponge

Spattering

Alcohol

MIXING WATERCOLORS

WET-ON-DRY This method involves applying different washes of color on dry watercolor paper and allowing the colors to intermingle, creating interesting edges and blends.

MIXING IN THE PALETTE VS. MIXING WET-ON-DRY To experience the difference between mixing in the palette and mixing on the paper, create two purple shadow samples. Mix ultramarine blue and alizarin crimson in your palette until you get a rich purple; then paint a swatch on dry watercolor paper (A). Next paint a swatch of ultramarine blue on dry watercolor paper. While this is still wet, add alizarin crimson to the lower part of the blue wash, and watch the colors connect and blend (B). Compare the two swatches. The second one (B) is more exciting. It uses the same paints but has the added energy of the colors mixing and moving on the paper. Use this mix to create dynamic shadows.

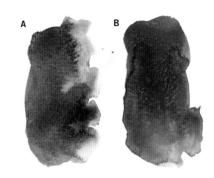

VARIEGATED WASH A variegated wash differs from the wet-on-dry technique in that wet washes of color are applied to wet paper instead of dry paper. The results are similar, but using wet paper creates a smoother blend of color. Using clear water, stroke over the area you want to paint and let it begin to dry. When it is just damp, add washes of color and watch them mix, tilting your paper slightly to encourage the process.

APPLYING A VARIEGATED WASH After applying clear water to your paper, stroke on a wash of ultramarine blue (left). Immediately add some alizarin crimson to the wash (center), and then tilt to blend the colors further (right). Compare this with your wet-on-dry purple shadow to see the subtle differences caused by the initial wash of water on the paper.

GLAZING is a traditional watercolor technique that involves two or more washes of color applied in layers to create a luminous, atmospheric effect. Glazing unifies the painting by providing an overall underpainting (or background wash) of consistent color.

CREATING A GLAZE To create a glazed wash, paint a layer of ultramarine blue on your paper (far left). Your paper can either be wet or dry. After this wash dries, apply a wash of alizarin crimson over it (near left). The subtly mottled purple that results is made up of individual glazes of transparent color.

Color Theory

Acquaint yourself with the ideas and terms of color theory, which involve everything from color relationships to perceived color temperature and color psychology. In the following pages, we will touch on the basics as they relate to painting.

COLOR WHEEL

The color wheel, pictured to the right, is the most useful tool for understanding color relationships. Where the colors lie relative to one another can help you group harmonious colors and pair contrasting colors to communicate mood or emphasize your message. The wheel can also help you mix colors efficiently. Below are the most important terms related to the wheel.

Primary colors are red, blue, and yellow. With these you can mix almost any other color; however, none of the primaries can be mixed from other colors. Secondary colors include green, orange, and violet. These colors can be mixed using two of the primaries. (Blue and yellow make green, red and yellow make orange, and blue and red make violet.) A tertiary color is a primary mixed with a near secondary, such as red with violet to create red-violet.

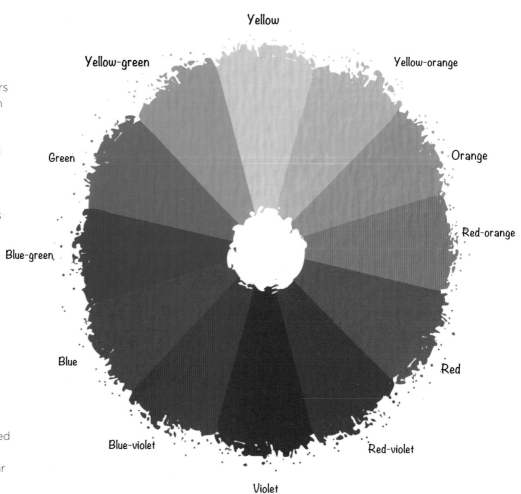

Yellow
Yellow-green
Yellow-orange
Green
Orange
Blue-green
Red-orange
Blue
Red
Blue-violet
Red-violet
Violet

COMPLEMENTARY COLORS are those situated opposite each other on the wheel, such as purple and yellow. Complements provide maximum color contrast.

ANALOGOUS COLORS are groups of colors adjacent to one another on the color wheel, such as blue-green, green, and yellow-green. When used together, they create a sense of harmony.

NEUTRAL COLORS are browns and grays, both of which contain all three primary colors in varying proportions. Neutral colors are often dulled with white or black. Artists also use the word "neutralize" to describe the act of dulling a color by adding its complement.

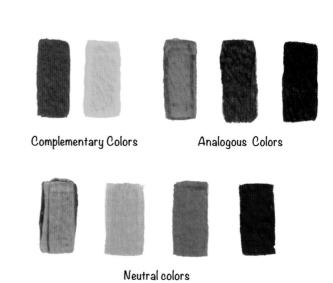

Complementary Colors Analogous Colors

Neutral colors

Transferring a Drawing

There are many options available to transfer a subject image onto drawing paper or canvas, including using transfer paper, the grid method, or the projector method.

TRANSFER PAPER

On a sheet of thin drawing or tracing paper, sketch out your composition until you are satisfied. Take a piece of transfer paper (sold in art stores) and tape it over the white paper surface you have chosen for your final drawing. There is a coating of graphite on the bottom of the transfer paper. Tape your drawing or tracing paper over the transfer paper. Using a ballpoint pen or stylus, impress the outlines of your drawing with medium pressure. Raise both papers, and you will see the graphite image on your final white paper. Erase the transferred graphite lines if needed as you develop the drawing. Of course, you can always freehand your composition directly onto the final paper. Sketch lightly and erase well.

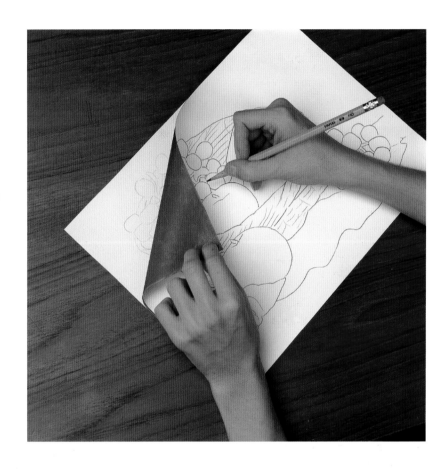

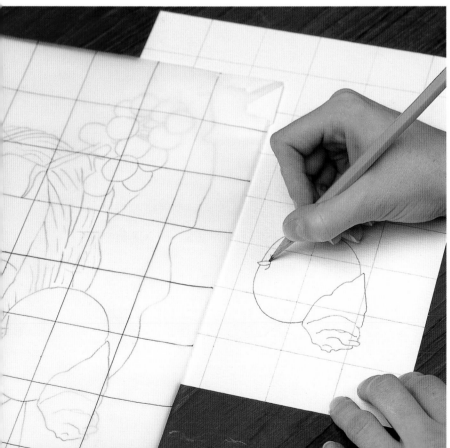

GRID METHOD This method enables you to sketch out your drawing in small segments using one-inch squares. Photocopy your photo reference and draw a grid of one-inch squares over the photocopy with a pen and ruler. Then very lightly draw the same grid of one-inch squares with a graphite pencil onto your final drawing paper. Starting from left to right, draw what you see in each square. Connect your composition from box to box until it is done. Erase your grid lines.

PROJECTOR METHOD Secure your projector to a countertop and tape your photo inside its top. The photo reflects off a lighted mirror, through a lens, and onto your final paper. Trace the basic outlines of the photo onto your drawing paper. Once the sketch is on paper, you can then focus on creating a perfectly proportioned piece as you refine lines, add detail, and build up tone.

BASIC SKETCHING

Floral Arrangement

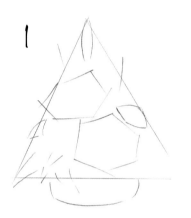

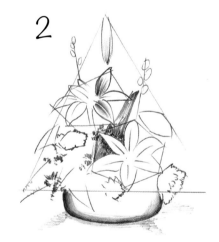

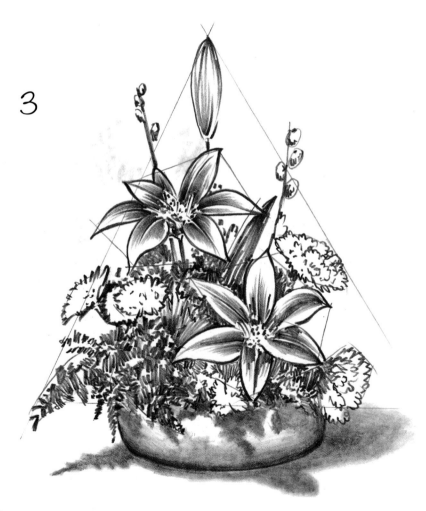

1 Begin with an HB pencil, lightly drawing in the basic shapes within the floral arrangement.

2 Continue using a loose, sketchy technique. Sometimes this type of final can be more pleasing than a highly detailed one.

3 The final sketch shows shading strokes for the flower petals and leaves. Try not to add too much detail, but keep strokes light. Position the shadows using the side of an HB pencil; then blend softly with a paper stump.

Liquid and Glass

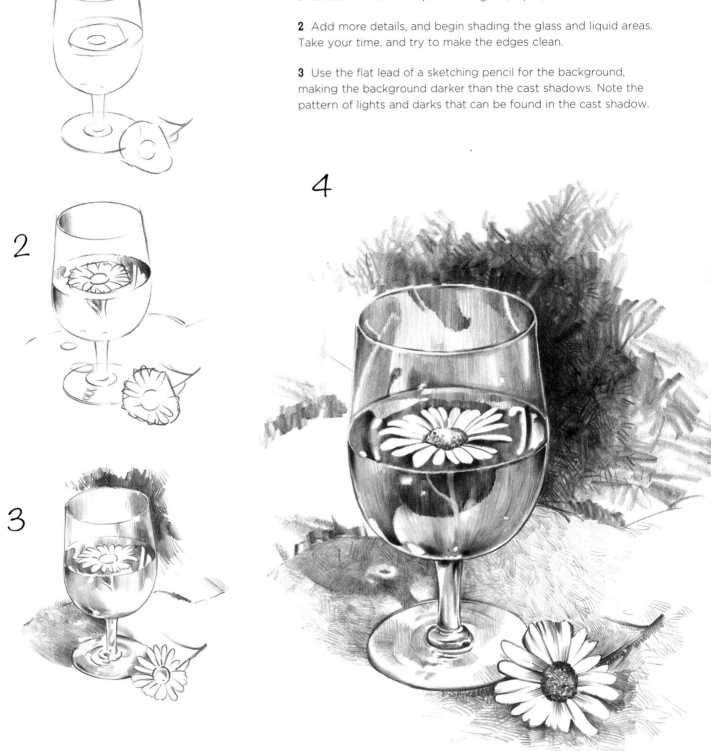

1 Sketch the basic shapes of the glass, liquid, and flowers.

2 Add more details, and begin shading the glass and liquid areas. Take your time, and try to make the edges clean.

3 Use the flat lead of a sketching pencil for the background, making the background darker than the cast shadows. Note the pattern of lights and darks that can be found in the cast shadow.

4 Use the finished drawing as your guide for completing lights and darks. If pencil smudges accidentally get in the highlights, clean them out with a kneaded eraser. Then use sharp-pointed HB and 2B pencils to add final details.

23

Rose

1

2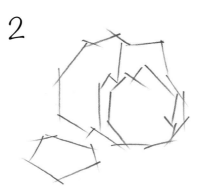

3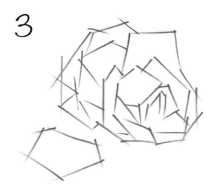

1 Use an HB pencil to block in the overall shapes of the rose and petal, using a series of angular lines.

IN STEPS 2–3, Continue adding guidelines for the flower's interior, following the angles of the petal edges.

Make the cast shadow the darkest area of your drawing.

4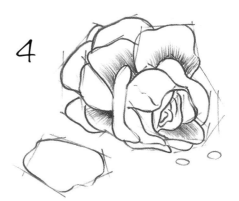

5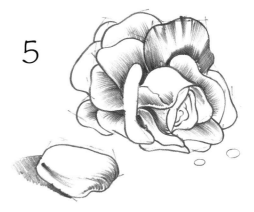

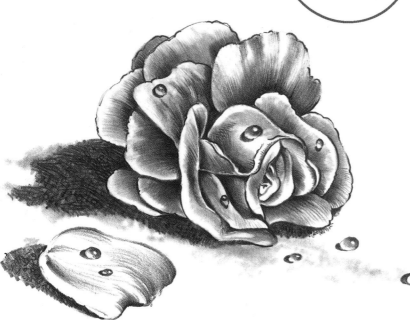

4 Now begin shading and refining the shape. Stroke from inside each petal toward its outer edge.

5 Shade from the outer edge of each petal, meeting the strokes you drew in the opposite direction. Draw lines that gently fade at the end.

Gardenia

1

2

1 With straight lines, block in an irregular polygon for the overall flower shape and add partial triangles for leaves.

2 As you draw each of the petal shapes, pay particular attention to where they overlap and to their proportions—how big each is compared with the others. Accurately reproducing the pattern of the petals is an important element.

3 Once all the shapes are laid in, refine their outlines. Using the side and blunt point of an HB pencil, shade the petals and the leaves, making your strokes follow the direction of the curves.

Hatch strokes are parallel diagonal lines. Draw them close together for dark shadows; space them apart for lighter values.

3

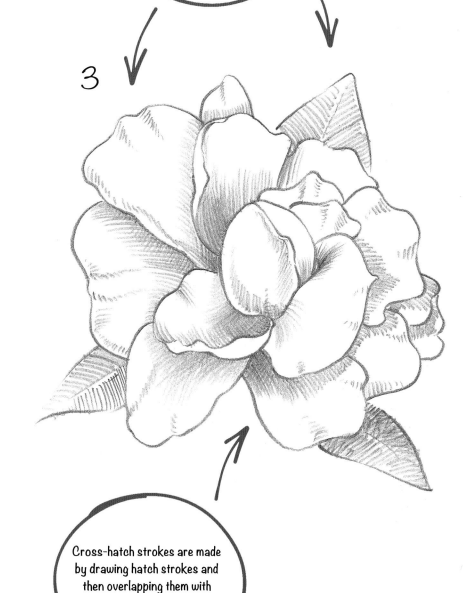

Cross-hatch strokes are made by drawing hatch strokes and then overlapping them with hatch strokes angled in the opposite direction.

Floral Bouquet

1 Draw the basic shapes of the roses with an HB pencil. Block in only the outlines and a few major petal shapes.

2 Begin developing the secondary shapes of each flower. These are the elements that make each rose unique, so pay careful attention to the shapes at this stage.

3 Begin to define the shapes more precisely, adding detail to the innermost petals, refining the stems, and developing the shape of the ribbon.

4 Keep shading fairly minimal. Use hatched strokes and add only enough shading on each flower, leaf, and stem to give it some form.

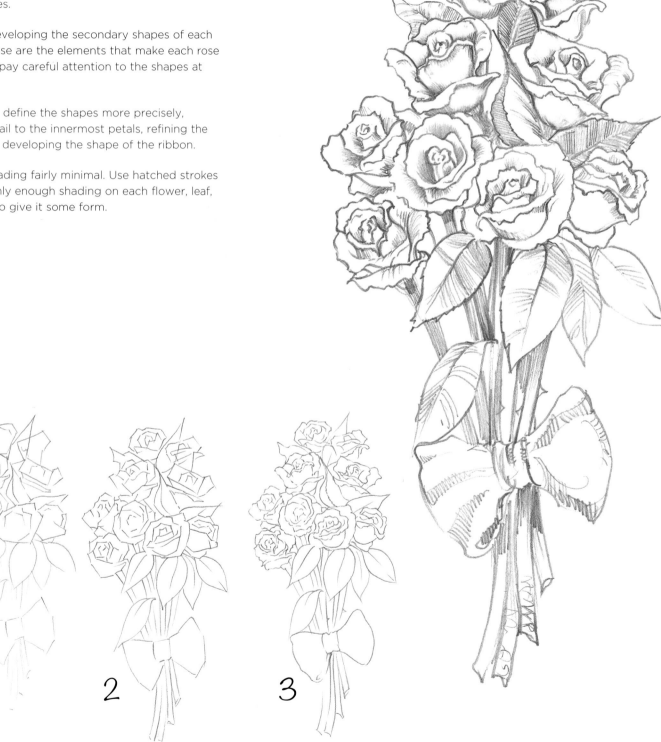

4

1

2

3

Tulip

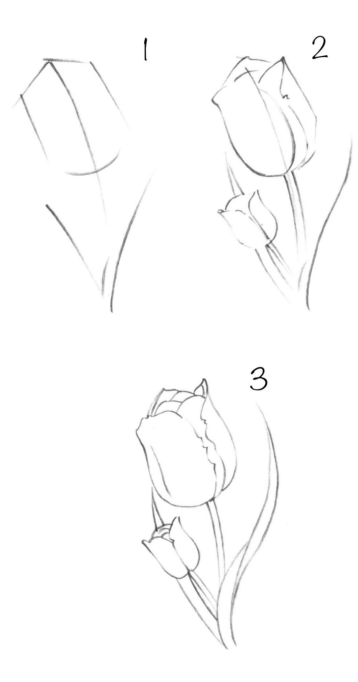

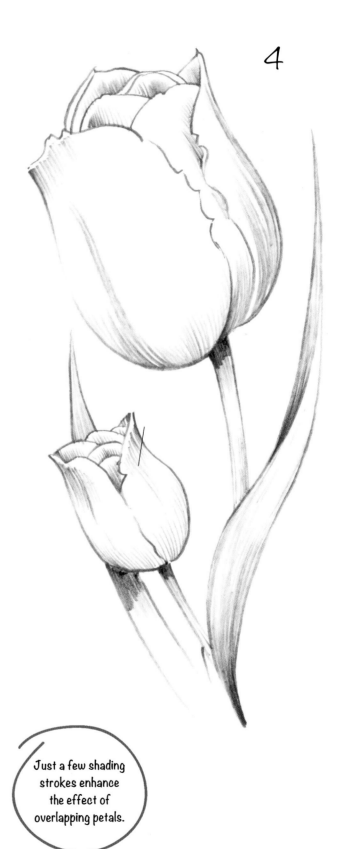

CREATING FORM Look for the rhythm of line in the tulip. It begins with simple lines in step 1, which set its basic direction. Step 2 demonstrates how to add lines to build the general flower shape. Step 3 adds more to the flower shape. Step 4 shows more detail and shading, which gives the flower its form.

Just a few shading strokes enhance the effect of overlapping petals.

Carnation

1 Develop the overall shape of the side view, including the stem and sepal.

2 Begin drawing the intricate flower details, keeping them light and simple.

A dark background allows the flower to pop off the page.

1

3

2

1 The front view above shows the complex pattern of this carnation. Draw the basic shapes of the flower. Then draw the curved petal shapes.

2 Shade the flower.

The crinkled petals evolve from drawing irregular edges and shading unevenly in random areas.

1

2

Peony

1 Begin the exercise by drawing and positioning the major flower parts.

2 Begin refining the petals and surrounding leaves.

3 Start shading and establish the background pattern.

Draw this project on vellum-finish Bristol board. On this surface, shading produces a bit more texture than the smoother plate finish.

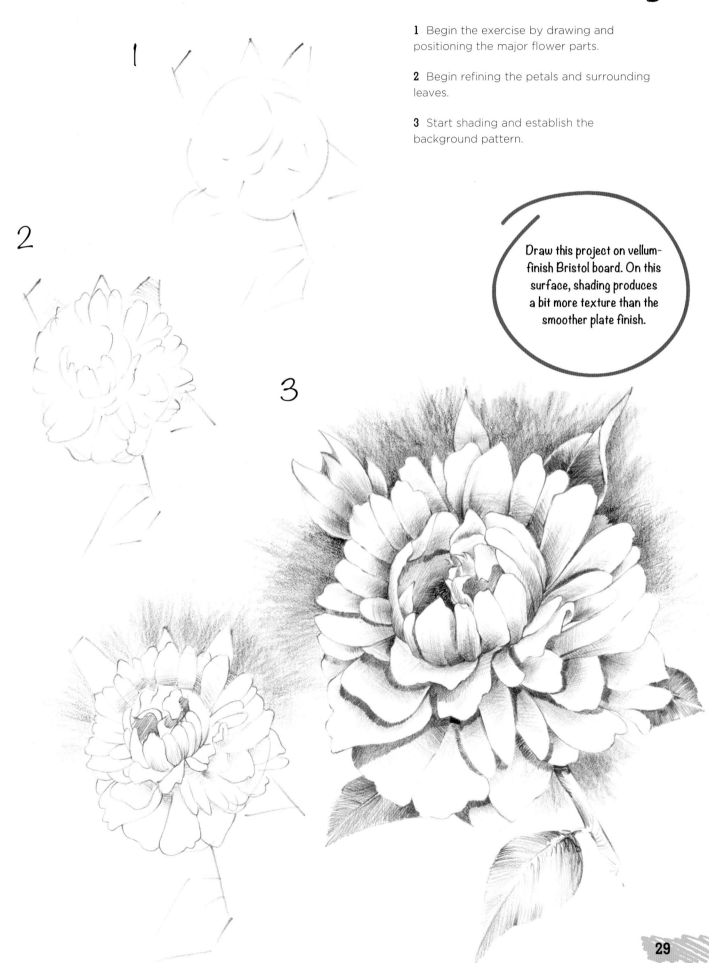

Lily

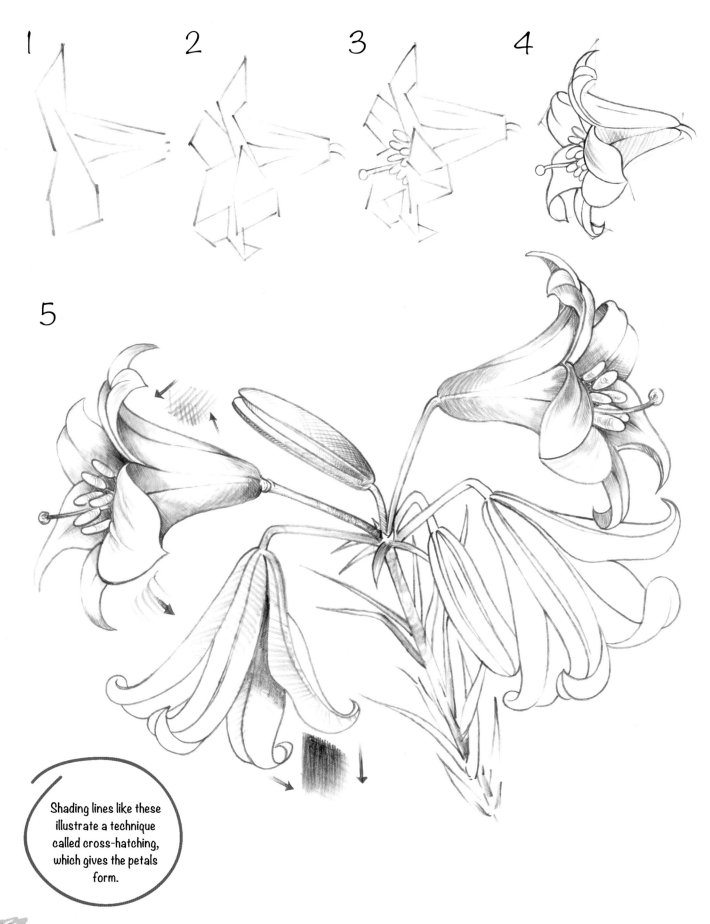

1

2

3

4

5

Shading lines like these illustrate a technique called cross-hatching, which gives the petals form.

Primrose

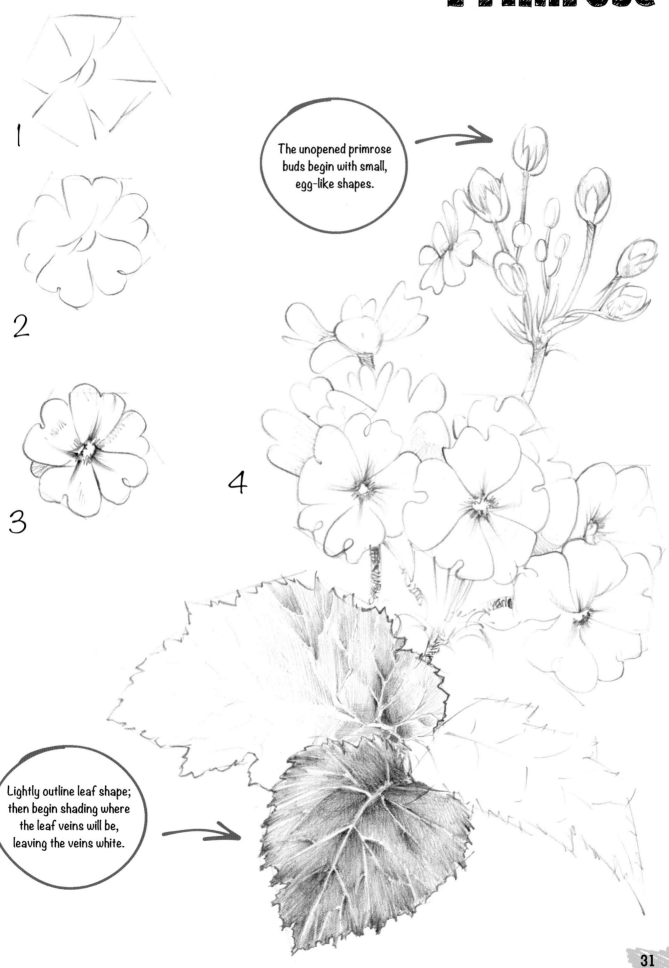

1

2

3

4

The unopened primrose buds begin with small, egg-like shapes.

Lightly outline leaf shape; then begin shading where the leaf veins will be, leaving the veins white.

Hibiscus

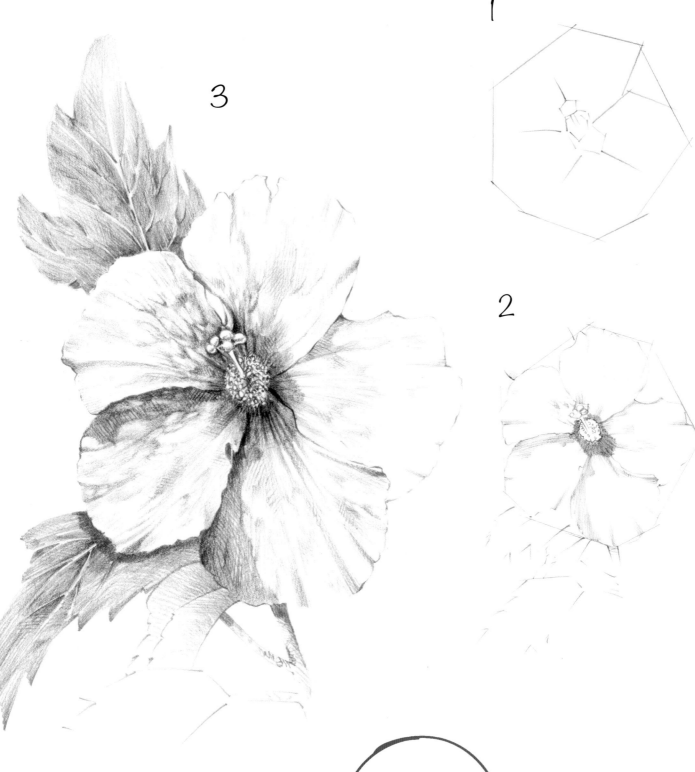

1

2

3

1 Sketch the overall mass, petal direction, and basic center of the flower.

2 Refine the details, and give the petals a slightly rippled effect.

3 Add the details of the flower center, and block in the stem and leaves.

Draw a few buds, and attach them to stem branches around your drawing for variety.

Tea Rose

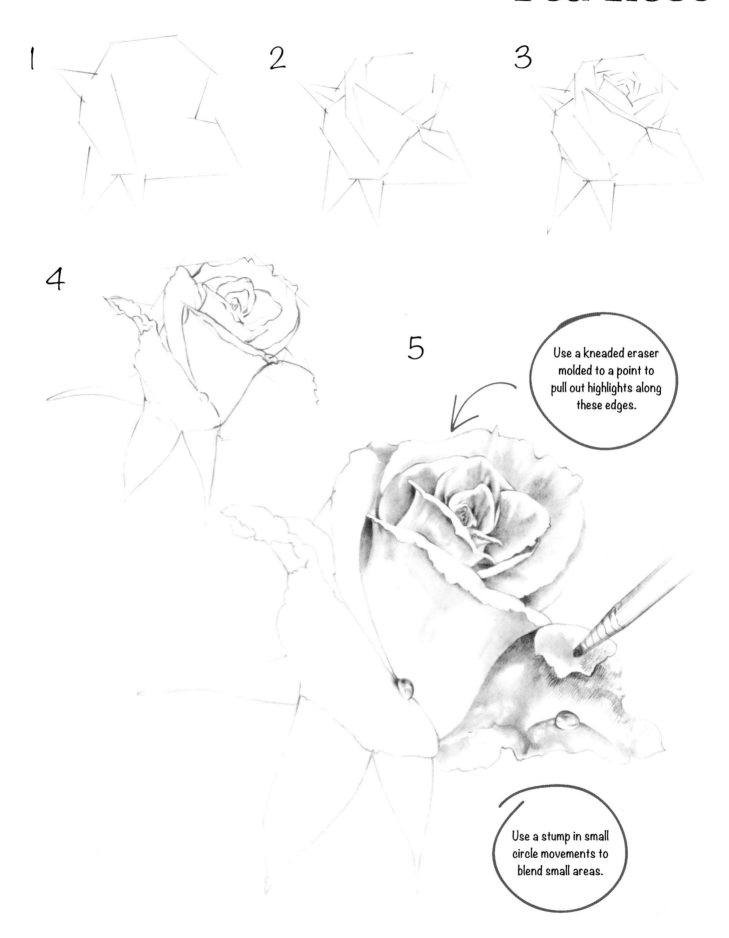

1

2

3

4

5

Use a kneaded eraser molded to a point to pull out highlights along these edges.

Use a stump in small circle movements to blend small areas.

Bearded Iris

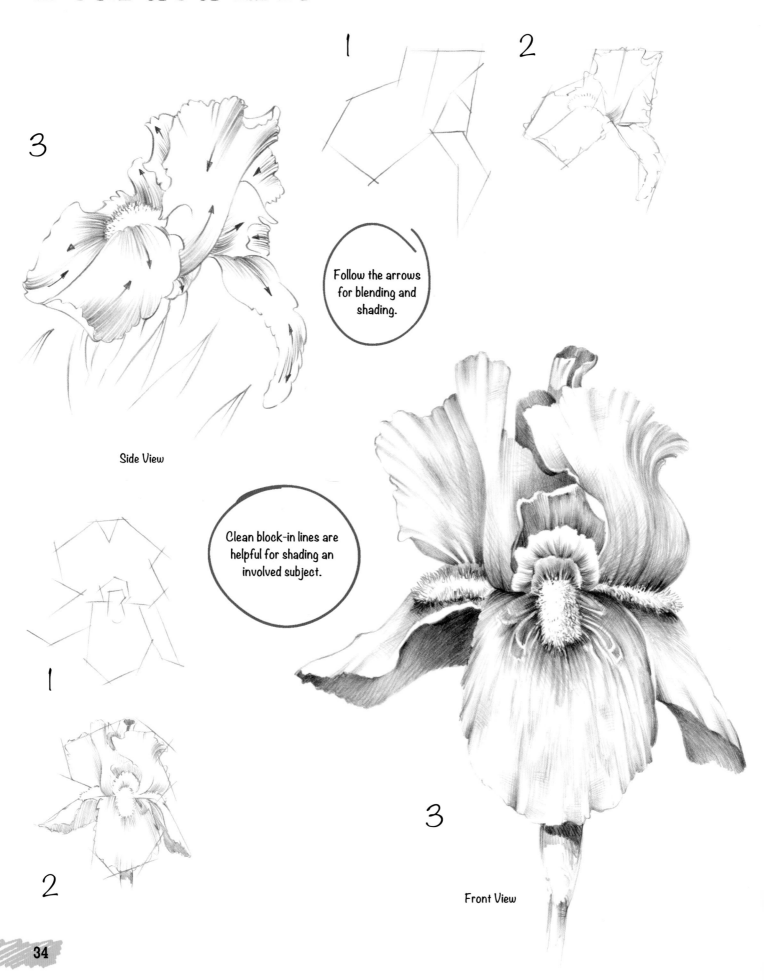

1

2

3

Follow the arrows for blending and shading.

Side View

Clean block-in lines are helpful for shading an involved subject.

1

2

3

Front View

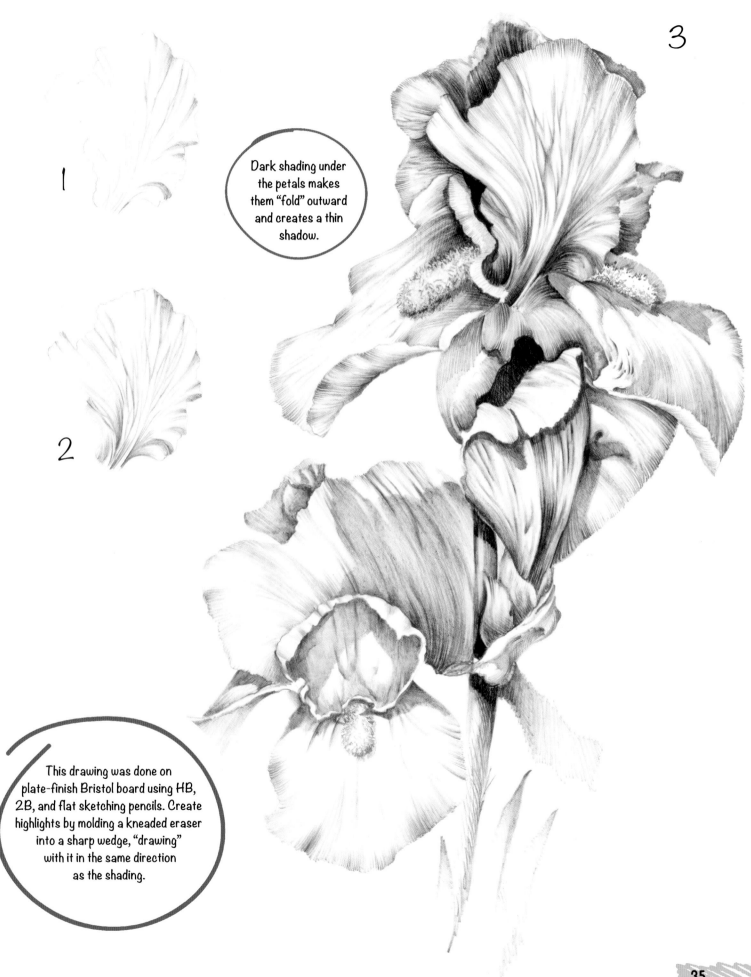

1

2

3

Dark shading under the petals makes them "fold" outward and creates a thin shadow.

This drawing was done on plate-finish Bristol board using HB, 2B, and flat sketching pencils. Create highlights by molding a kneaded eraser into a sharp wedge, "drawing" with it in the same direction as the shading.

CHAPTER 2
GRAPHITE PENCIL

Calla Lily

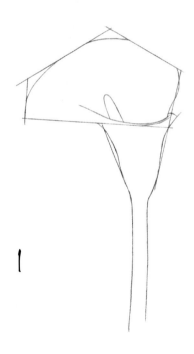

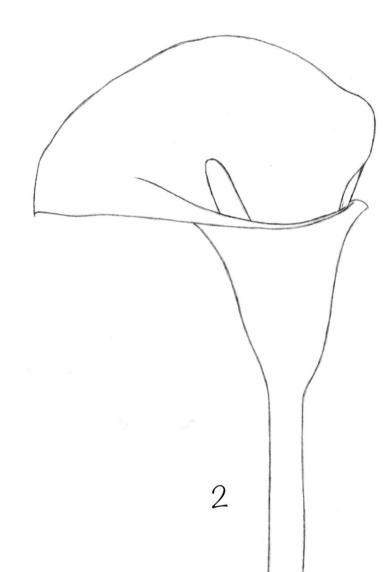

1 Start this drawing on heavy tracing vellum, using an HB pencil and straight lines to block in the basic shapes. Then refine the outline of the flower, rounding off the bottom of the blossom and transitioning into the straight, thick stem.

2 Take a second piece of tracing vellum and trace over the outline, adding more variation to the overall shape to create a better sense of natural realism. Transfer the outline to a sheet of smooth-finish Bristol paper.

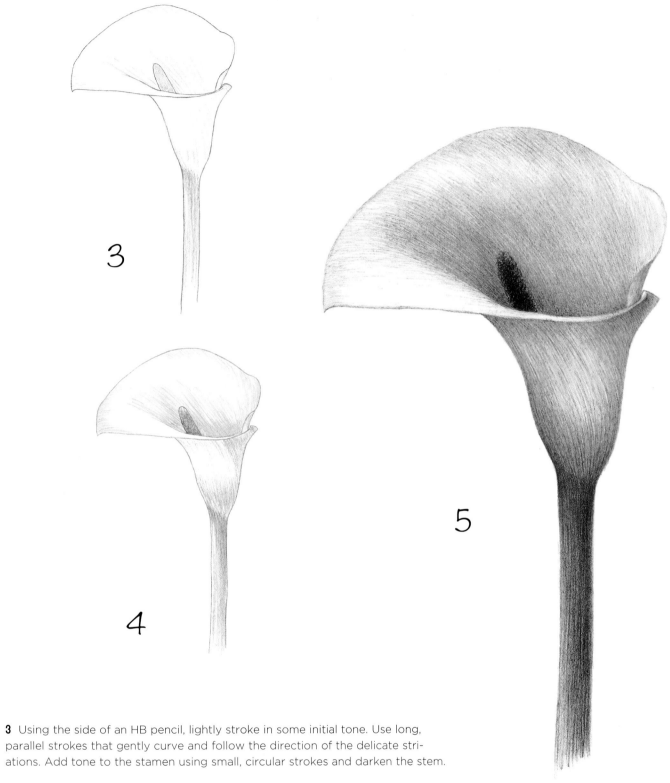

3 Using the side of an HB pencil, lightly stroke in some initial tone. Use long, parallel strokes that gently curve and follow the direction of the delicate striations. Add tone to the stamen using small, circular strokes and darken the stem.

4 Continue to build up the tone using the HB pencil. Then switch to a 2B pencil and darken the stem using long, vertical strokes. With heavier pressure and small circular strokes, deepen the tone of the stamen.

5 Continue to build up the tone of the flower head using the HB pencil. Then use an eraser to pull out some highlights along the outer edges of the petal. Further darken the stem and stamen. Finally, use the point of the pencil to reinforce the edges of the flower, creating a subtle contrast between the white flower and the white background.

TULIP

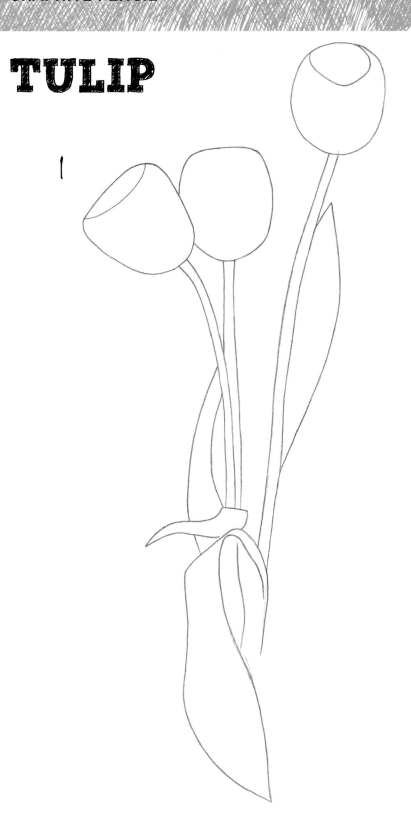

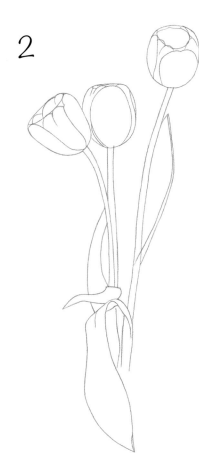

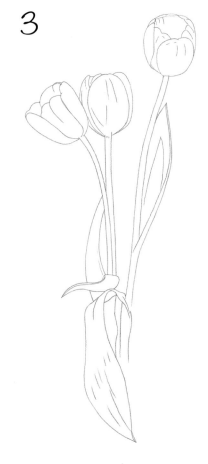

1 Using an HB pencil and tracing vellum, draw the curves of the stems using long, graceful lines. Block in ovals to represent the flower heads and irregular ellipses where the insides of the cups are visible. Sketch the leaves.

2 Now draw the petals, using the ovals and ellipses as guides. Use curved lines and oval shapes to draw the petals. Refine the leaves as needed.

3 Place a new piece of tracing vellum on top of the drawing; then retrace and refine the flowers, leaves, and stems. Erase the ellipses, and add some lines to represent a few striations. Transfer the drawing to smooth-finish Bristol paper, keeping the lines as light as possible.

4 Begin adding shadows and highlights using strokes that follow the form of the flower. Apply some graphite to the leaves; then add some tone to the stems near the base of the flower heads.

5 Continue developing the tone of the tulips. Darken the cast shadow on the middle tulip. Continue to shade the leaves.

6 Use a sharp HB to continue shading the petals and a 2B for the darkest shadows and the insides of the flowers. Switch to a 2H to further define the petal edges. Then lift out the highlights on the flower heads with a kneaded eraser. For the leaves, use a 2B pencil and allow the individual strokes to remain visible to create a leaf-like texture. Shade the stems like a cylinder, keeping the side facing the light much lighter.

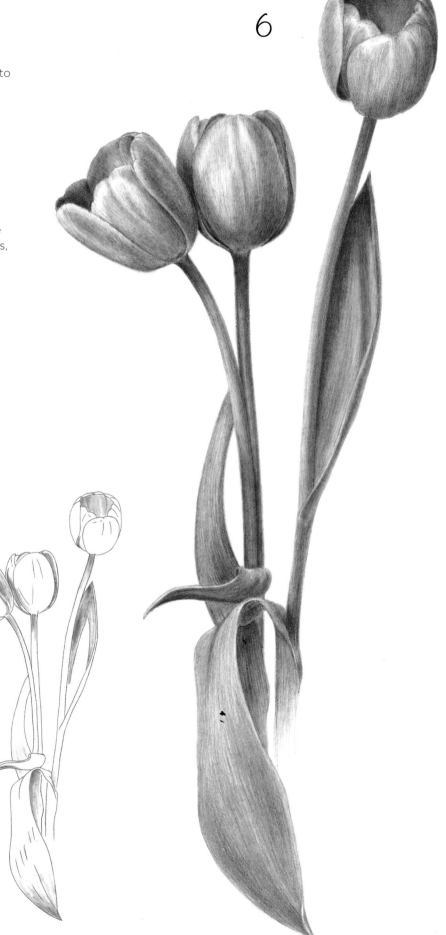

6

4

5

Hibiscus

1 Use an HB pencil to block in the outer shape of the flower using six straight lines. Block in the general shapes of the leaves and the closed bud.

2 Refine the petals, being mindful of their proportions and angles. Continue to use straight lines to suggest the shapes. Draw a polygon to define the center of the flower, parallel lines for the long filament and style, and polygons to block in the stigma and anther.

3 Indicate the major folds of the petals and the details of the pistil and stamen. Draw the details of the bud and sketch light lines to indicate venation on the leaves.

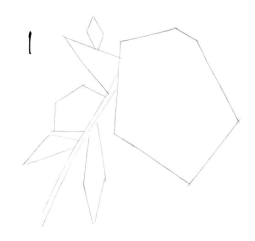

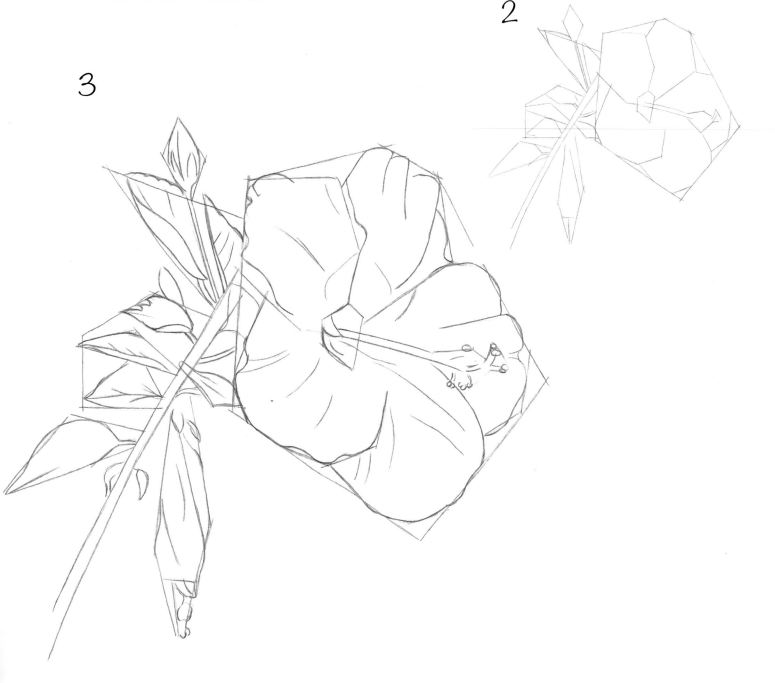

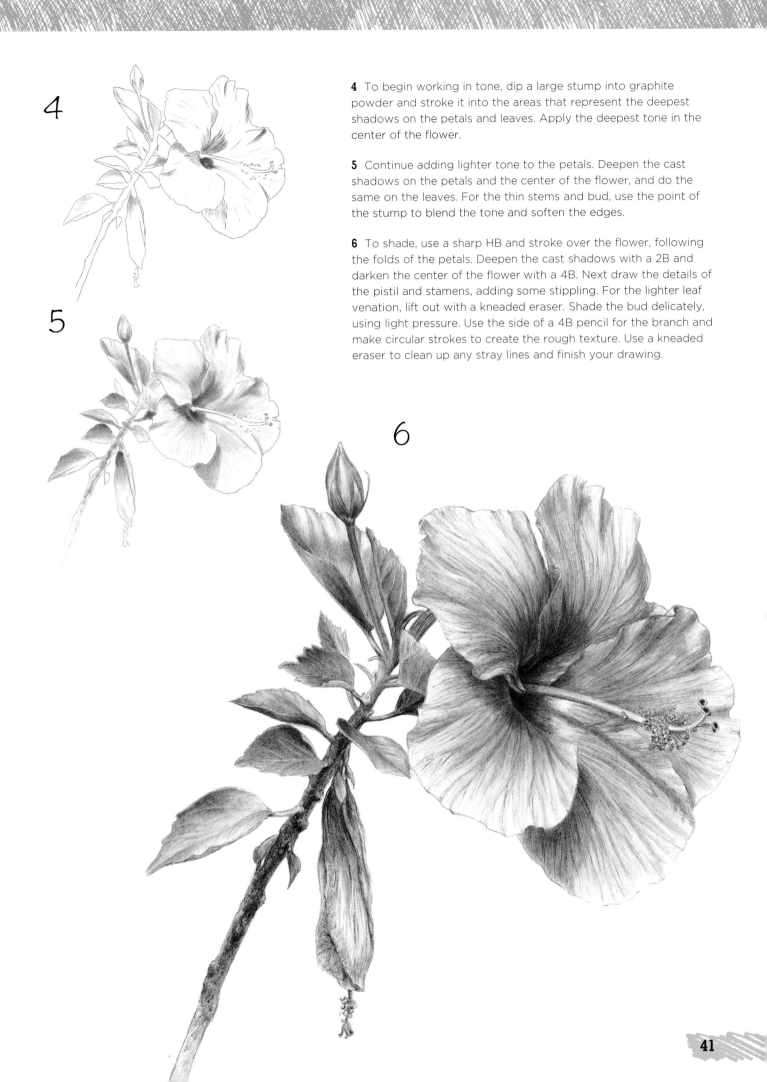

4 To begin working in tone, dip a large stump into graphite powder and stroke it into the areas that represent the deepest shadows on the petals and leaves. Apply the deepest tone in the center of the flower.

5 Continue adding lighter tone to the petals. Deepen the cast shadows on the petals and the center of the flower, and do the same on the leaves. For the thin stems and bud, use the point of the stump to blend the tone and soften the edges.

6 To shade, use a sharp HB and stroke over the flower, following the folds of the petals. Deepen the cast shadows with a 2B and darken the center of the flower with a 4B. Next draw the details of the pistil and stamens, adding some stippling. For the lighter leaf venation, lift out with a kneaded eraser. Shade the bud delicately, using light pressure. Use the side of a 4B pencil for the branch and make circular strokes to create the rough texture. Use a kneaded eraser to clean up any stray lines and finish your drawing.

Freesia

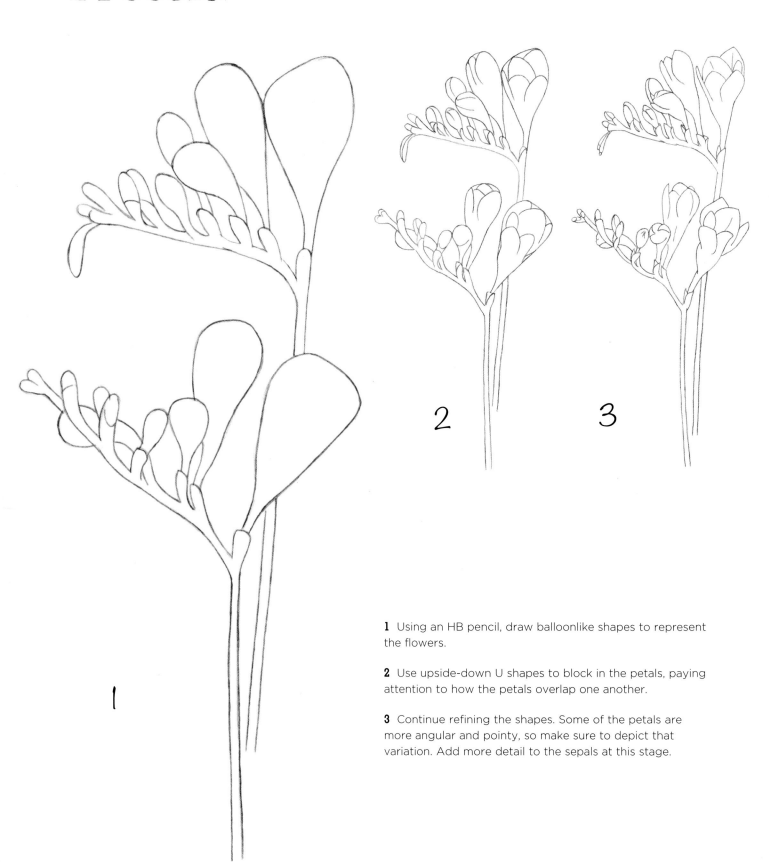

1 Using an HB pencil, draw balloonlike shapes to represent the flowers.

2 Use upside-down U shapes to block in the petals, paying attention to how the petals overlap one another.

3 Continue refining the shapes. Some of the petals are more angular and pointy, so make sure to depict that variation. Add more detail to the sepals at this stage.

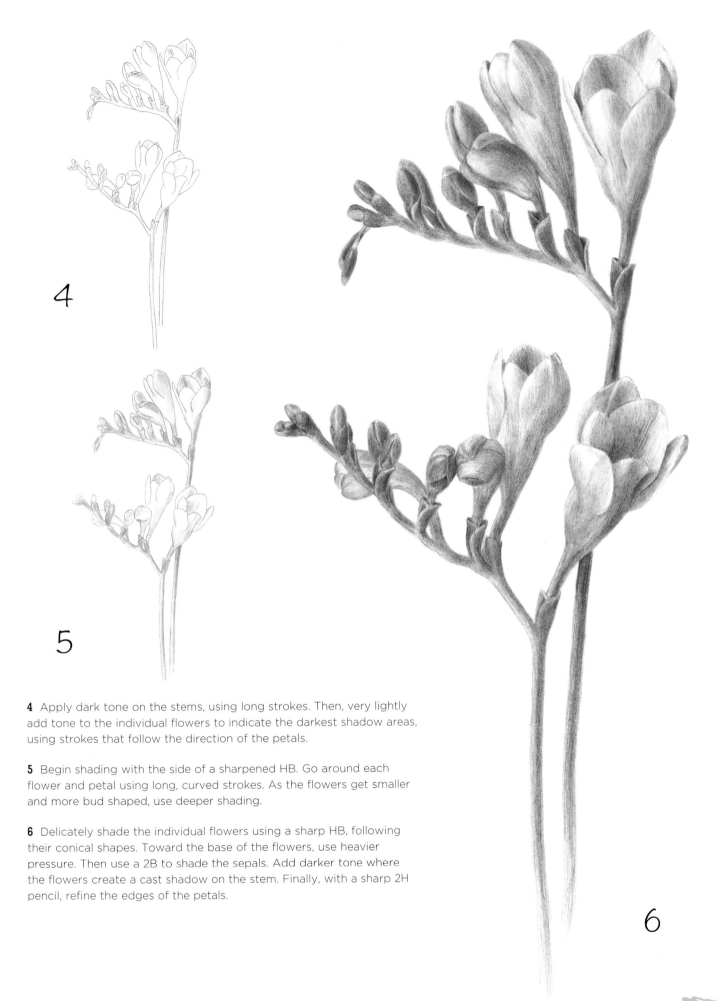

4 Apply dark tone on the stems, using long strokes. Then, very lightly add tone to the individual flowers to indicate the darkest shadow areas, using strokes that follow the direction of the petals.

5 Begin shading with the side of a sharpened HB. Go around each flower and petal using long, curved strokes. As the flowers get smaller and more bud shaped, use deeper shading.

6 Delicately shade the individual flowers using a sharp HB, following their conical shapes. Toward the base of the flowers, use heavier pressure. Then use a 2B to shade the sepals. Add darker tone where the flowers create a cast shadow on the stem. Finally, with a sharp 2H pencil, refine the edges of the petals.

Heliconia

1 Use an HB pencil and draw the two stems that converge. Then block in the large shapes of the heliconia flowers, using triangular shapes for the two lower bracts. Next draw the curved shapes of the bracts within the guidelines.

2 Add more details to the stem, and indicate the border of color changes along the bracts. Add lines to indicate the darker values.

3 Now take a 4B water-soluble graphite pencil and add tone to the stems, stroking along the form. Use long, slightly curved strokes where the form of the bract curves and linear strokes where it straightens out.

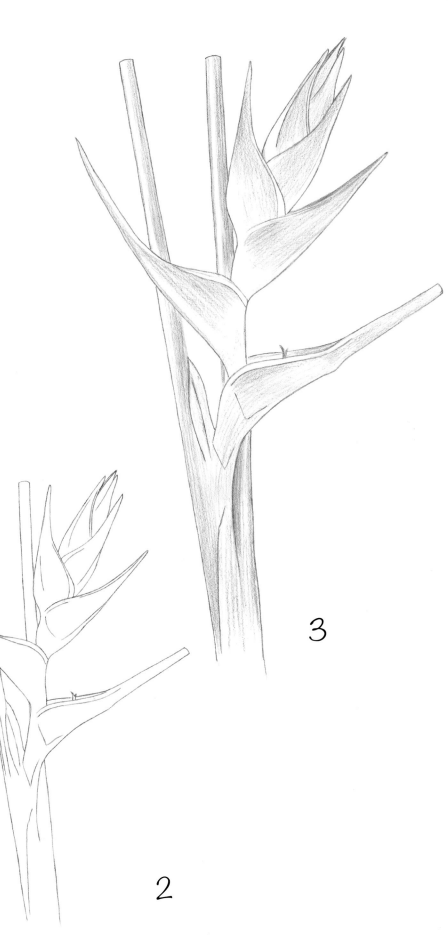

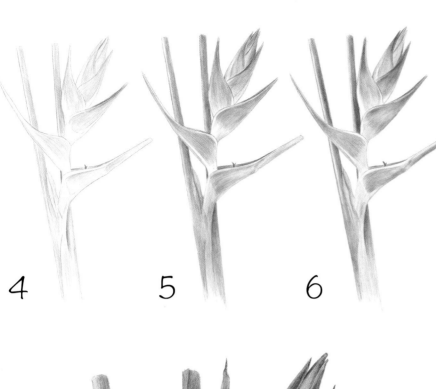

4 Dip a watercolor brush in water and gently roll it on a paper towel to absorb excess water and form a point. To create a softer undertone, drag the brush to allow the water to dissolve the graphite wherever you want soft edges.

5 Use the water-soluble pencil to deepen the tones in the shadowed areas. Use medium pressure along the stems, continuing the long strokes. For the bracts, use the heaviest pressure for the deepest values. To convey the light-valued, yellow areas of the stem near the bracts, use a light touch to add a bit of tone. Where the highlight falls in these areas, leave the paper white. Go over the entire drawing with the watercolor brush, smoothing out the tones.

6 Now use a dark 8B water-soluble pencil to further develop the darker tones. Use this along the stem, deepening the shadows. Darken the deep shadow inside the flower bract. Be careful to capture the striped border along the edge of the flower, using heavy pressure where the bract comes to a point and maintaining the light value of the yellow areas with the watercolor brush. Smooth out the tones.

7 When the paper is dry, use an HB graphite pencil and darken the entire drawing, smoothing out the tones. Use the point of the HB to refine the edges of the flower. For darker tones, use a 4B pencil. For the darkest darks, use a sharp point and heavier pressure. Further smooth out the tones using both a 2B and an HB. Finally, use a kneaded eraser to lift out tone, further refining the edges of the bracts and the highlights along the lighter areas.

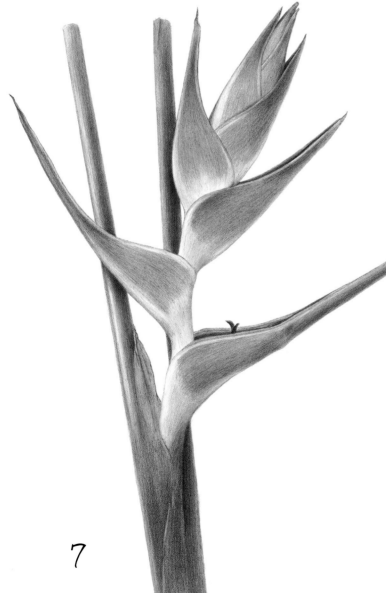

Ornithogalum

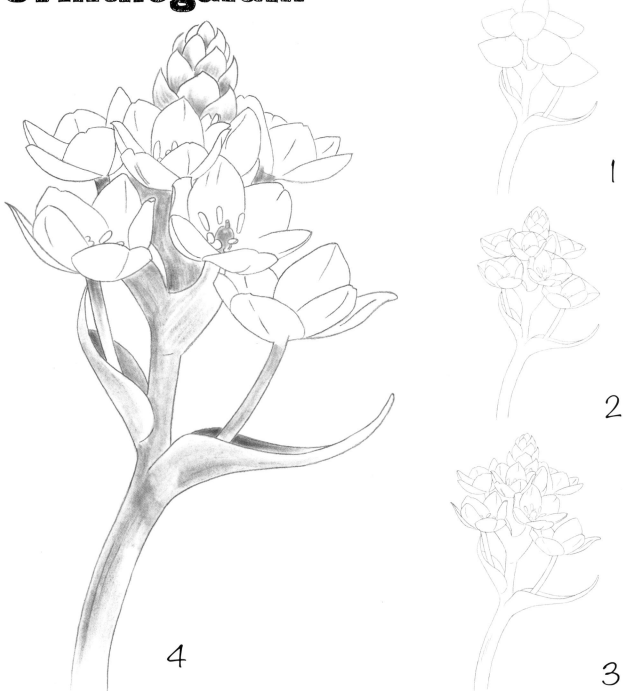

1

2

3

4

1 Use an HB pencil to draw the stem and leaves. Block in cup shapes to represent the flowers, flattening some and making others more pointed.

2 Now draw the individual petal shapes within the guidelines, using curved lines that come to a point.

3 Refine the petals, indicating subtle variations in their curves. Add a few curved lines to show the midline of some of the petals, which also helps give direction to the form.

4 Use graphite powder to apply dark tones on the stem, leaves, and upper part of the stalk. Add some tone to the shadows on the upper cluster and the visible stigma, as well as to the insides of the leaves.

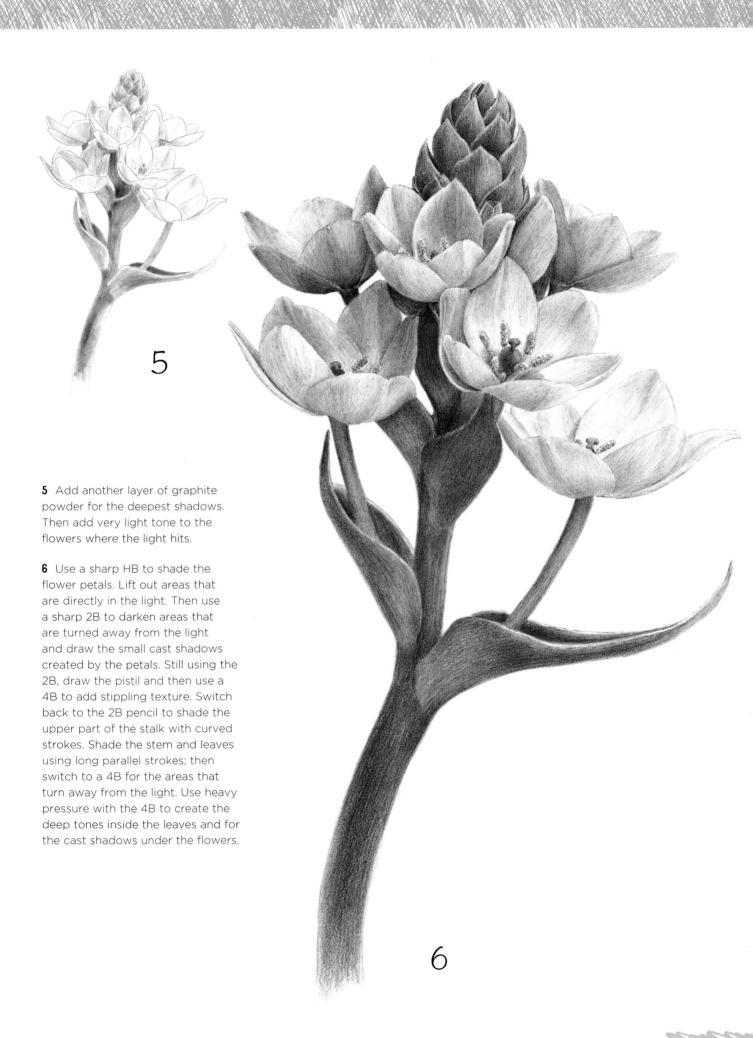

5 Add another layer of graphite powder for the deepest shadows. Then add very light tone to the flowers where the light hits.

6 Use a sharp HB to shade the flower petals. Lift out areas that are directly in the light. Then use a sharp 2B to darken areas that are turned away from the light and draw the small cast shadows created by the petals. Still using the 2B, draw the pistil and then use a 4B to add stippling texture. Switch back to the 2B pencil to shade the upper part of the stalk with curved strokes. Shade the stem and leaves using long parallel strokes; then switch to a 4B for the areas that turn away from the light. Use heavy pressure with the 4B to create the deep tones inside the leaves and for the cast shadows under the flowers.

CHAPTER 3
COLORED PENCIL

PALETTE

- Black
- Burnt ochre
- Canary yellow
- Crimson red
- Dark green
- Dark umber
- Goldenrod
- Indigo blue
- Jasmine
- Kelp green
- Olive green
- Orange
- Pumpkin orange
- Tuscan red
- White
- Yellow ochre
- Yellowed orange

Yellow Rose

1

2

3

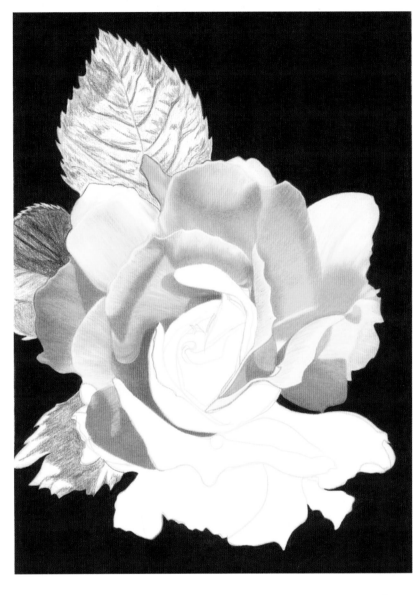

4

1 Sketch the rose using loose strokes.

2 Outline the interior petals with yellowed orange. Outline the exterior of the rose lightly with black to establish the background edging. Layer the large top petal with jasmine and yellowed orange; add orange in the dark areas. With yellow ochre and a burnishing of white, complete the base coat. Use pumpkin orange and a touch of crimson red in the reddish areas. Blend canary yellow over the entire petal with firm pressure. Use yellowed orange to build up the orange areas and white to lighten. Lightly shadow the base area with burnt ochre. Add jasmine and white highlights with touches of yellowed orange and canary yellow.

3 Still working on the outer petals, build up the shadow areas with burnt ochre and blend with yellowed orange and canary yellow. With these three pencils, along with pumpkin orange and orange, create the remaining petals above and around the center. For the bright reddish areas, add a crimson red topcoat; then use dark umber on the left petal, and burnish everything with white.

4 For the background, create a rich, dense hue first with black, then Tuscan red, indigo blue, and a final burnish of black. Give the background leaves an initial coat of black using light pressure.

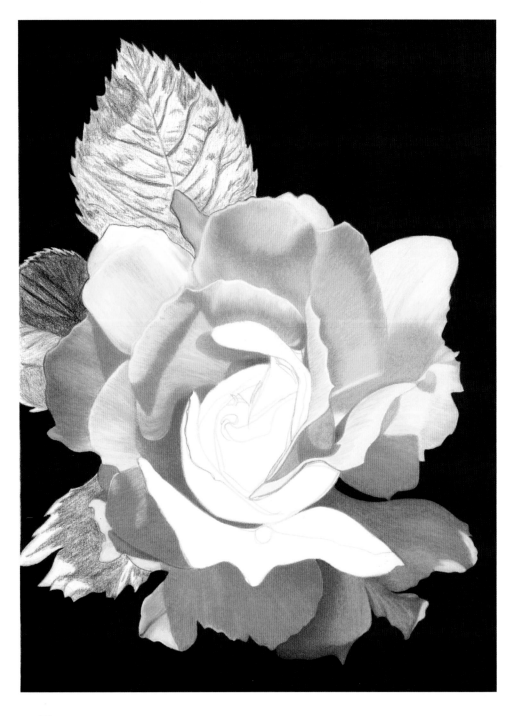

5

5 On the lower left petals, apply a jasmine wash with pumpkin orange. Then apply orange, crimson red, yellowed orange, and canary yellow. For the highlights, use jasmine, white, and pumpkin orange. Gently apply dark umber in the shadows to the right, and complete the bottom recessed petal using goldenrod with light streaks of crimson red and pumpkin orange. To finish the remaining back petals, add burnt ochre and goldenrod, as well as a light application of dark umber for the shadows. Touches of dark green and crimson red bring the petals to life. You can also add highlights with jasmine and white.

6 Add jasmine and pumpkin orange at the bud's base. Next layer yellowed orange over both sides and cover the red area to the left with Tuscan red. Use crimson red with a light, circular touch on both sides of the bud and canary yellow for the yellow areas. The interior of the bud is like a puzzle; complete it one piece at a time. For the orange areas, use yellowed orange, pumpkin orange, orange, and finally crimson red. Deepen the shadows and crevices with Tuscan red, and color the light yellow areas with canary yellow and white.

PETAL DETAIL Lightly outline the water drops and fill them in with goldenrod. Then blend them down with white.

LEAF DETAIL Finish each leaf by layering dark green, kelp green, and olive green over the existing black. Then add black back in and burnish with white for highlights.

6

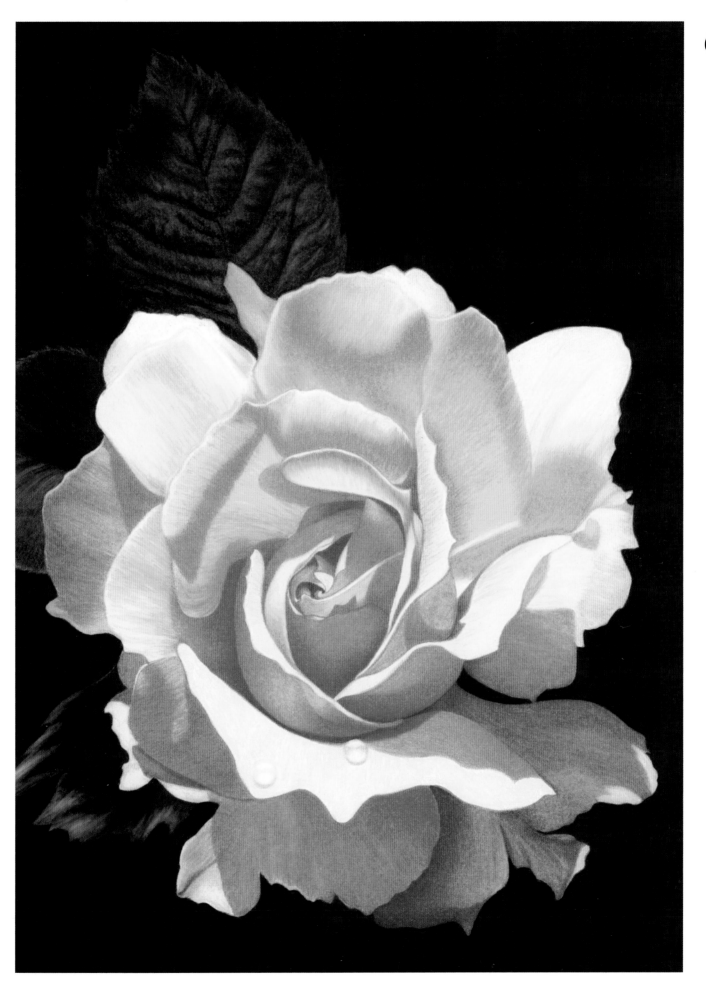

Daisy & Petunias

PALETTE

- Black
- Black grape
- Burnt ochre
- Cool gray 70%
- Dark green
- Dark purple
- Imperial violet
- Jasmine
- Magenta
- Mineral orange
- Poppy red
- Sunburst yellow
- Tuscan red
- Violet
- White

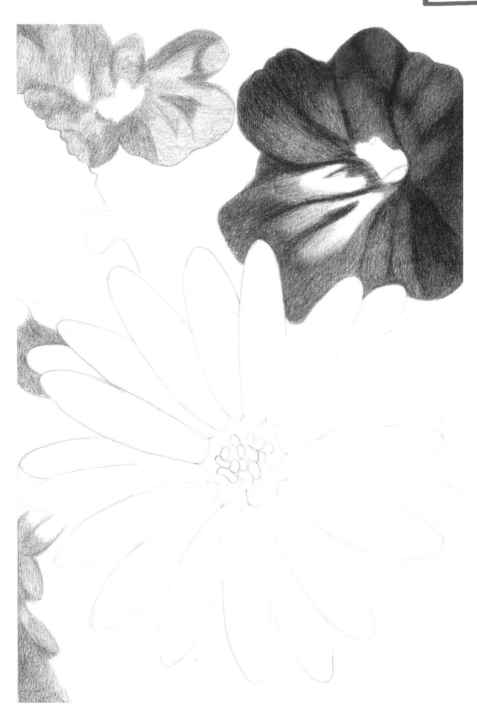

1 Sketch the outlines of this portrait with an H graphite pencil. Outline the petunias with black grape and add a base wash of violet. Leave the lighter areas white. Concentrate on the petunia in the upper right and darken it with additional layers of black grape and violet in small, circular strokes.

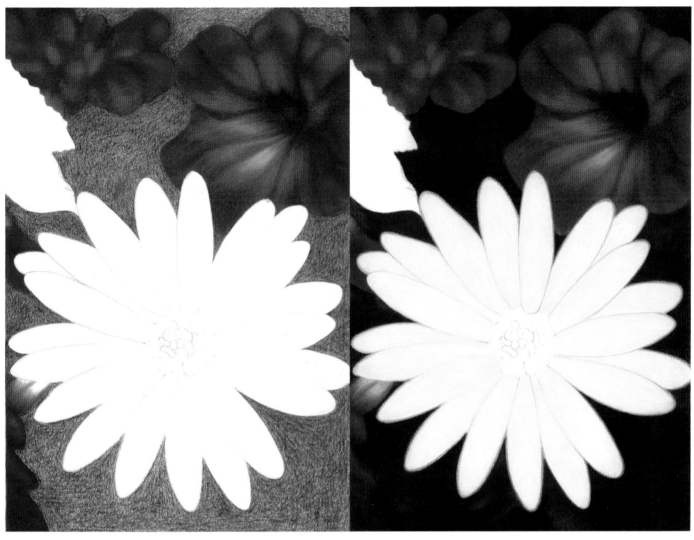

2

3

2 Still working on the petunia in the upper right, add a touch of imperial violet and burnish with white. With violet and black grape, darken select areas and add lines to form the petals. Finish the other background flowers with layers of violet, imperial violet, dark purple, and magenta. Burnish with white and lightly use black for depth. Over the remaining background, with the exception of the green leaves, add a light wash of black.

3 Continuing the background, use Tuscan red then dark green with medium pressure. Use white over the lighter areas; then reapply dark green. Finish with a black burnish over the darkest areas. Wash the daisy with jasmine and outline the petals with mineral orange.

Use small, rounded strokes around all the edges to create a blurred effect.

PETAL DETAIL In the dense black center of the petunia in the upper right, use black, black grape, and Tuscan red with a final burnishing of black.

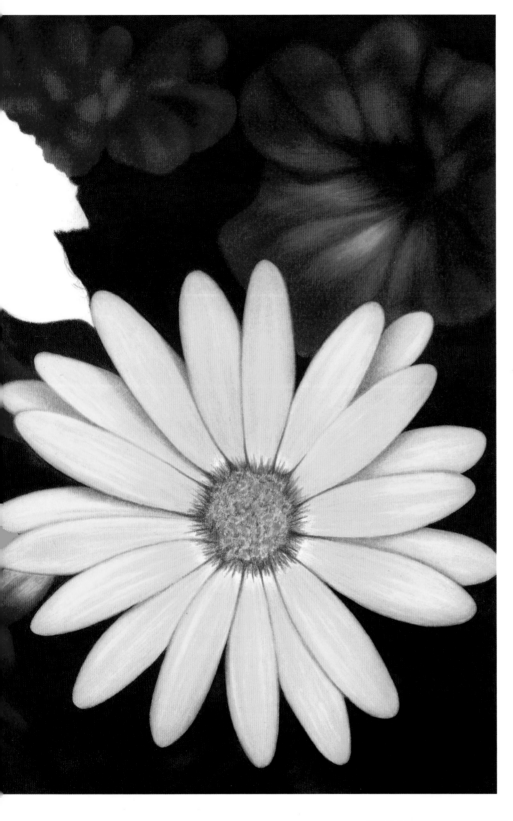

4 Fill in the petals with sunburst yellow and a light layer of mineral orange. Burnish with white and add streaks of mineral orange. In the shadows, lightly apply black grape, cool gray 70%, and burnt ochre. In the center, erase any graphite marks; then randomly scribble in the orange areas and apply poppy red on top. Form a few small splotches of burnt ochre and fill in all of the white areas with black grape, which extends into the base of the petals.

5 Add the background leaves with layers of black, and then dark green. Darken them by alternating between black, white, and dark green. Clean up the edges with a kneaded eraser; then add several sprays of workable fixative to seal the piece.

The term "wash" refers to a light application of color, generally the first layer. On a scale of 1 to 10, use a light pressure of three to four for a wash.

CENTER DETAIL Use medium pressure to finish the center by layering black then dark purple over the black grape. Extend the dark purple into the base of the petals. Finally, burnish with white, then use sunburst yellow and mineral orange to pull streaks of color into the burnished area.

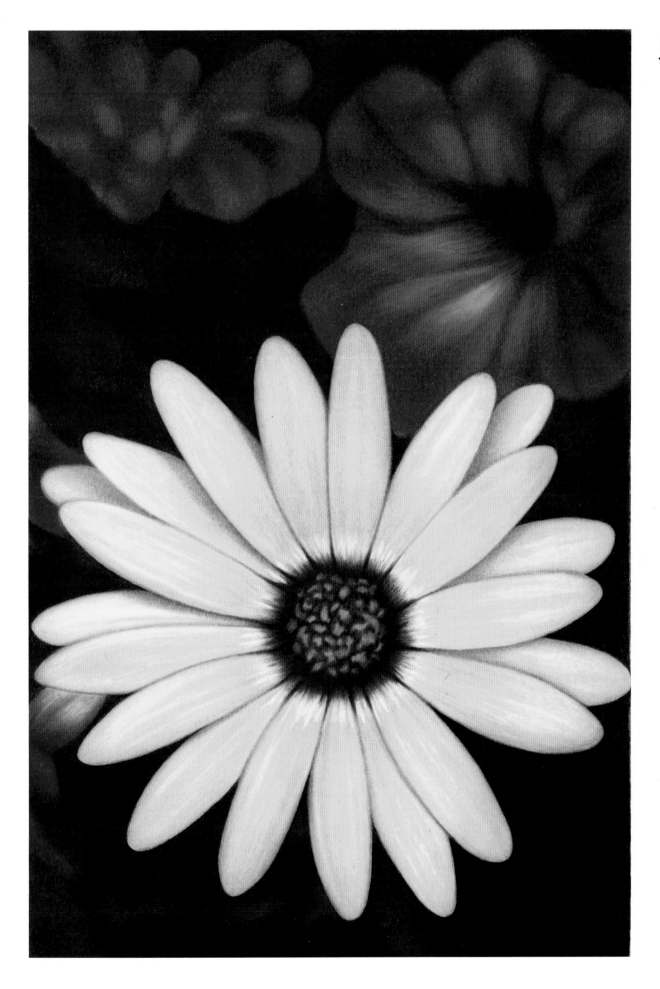

5

Tulips

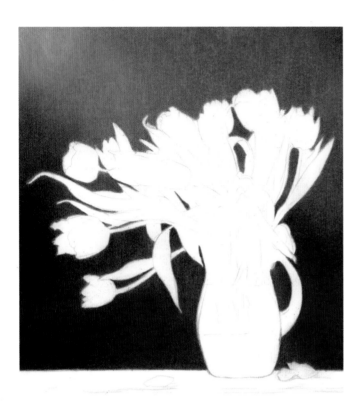

1

PALETTE

- Cool gray 30%
- Cool gray 50%
- Black
- Black grape
- Bronze
- Canary yellow
- Chartreuse
- Chocolate
- Crimson red
- Dahlia purple
- Dark green
- Dark umber
- Kelly green
- Kelp green
- Mineral orange
- Moss green
- Mulberry
- Spanish orange
- Spring green
- Tuscan red

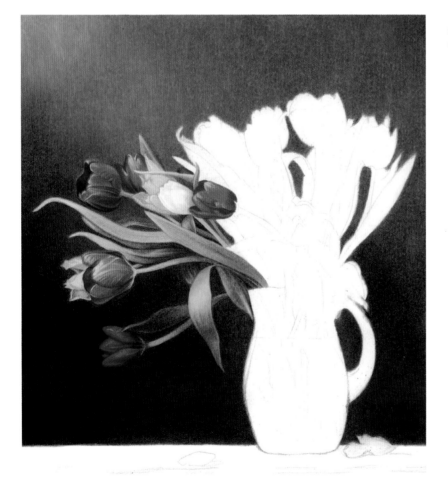

2

1 Sketch the image with cool gray 50%. Begin the background with light layers of kelp green and bronze, keeping your strokes vertical to simulate the textured backdrop. Burnish with white in the upper left corner, moving down diagonally to the floral arrangement. Darken the lower left corner with dark umber, black, and chocolate. Continue shading toward the vase with black, chocolate, kelp green, moss green, and bronze. To the right and above the flowers, shade with kelp green and moss green, adding streaks of canary yellow and chocolate. Apply black and chocolate with a sharp point for dark, dense accents in select areas. To achieve a smoothly gradated background, spend plenty of time blending. If colors are too harsh, use white to blend them down.

3

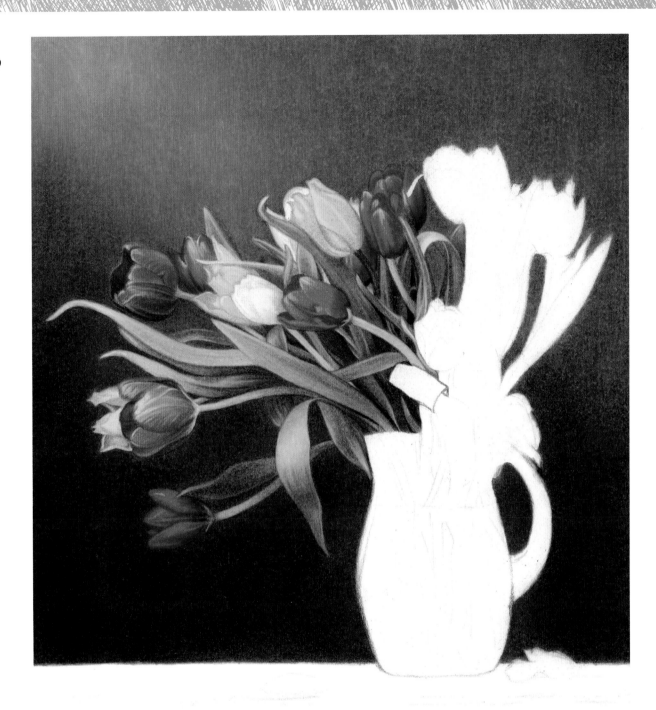

2 Start the greenery. Stroking along the length of each leaf, use chartreuse for the light areas and kelp green and chocolate for the dark areas. For the brightest highlights, layer spring green and white. Add crimson red to the flowers, adding Tuscan red and black to the darker areas. Use mulberry for the purple tulips, adding dahlia purple to the darker areas and crimson red and Tuscan red for warm accents. For the shadows, layer in black. For the yellow tulips, use canary yellow and mineral orange, adding Spanish orange to define the middle values. Add touches of chartreuse and crimson red to the base to suggest reflected light. Blend everything with white.

3 On the yellow tulip, outline the petals with Spanish orange and fill them in with canary yellow and touches of Spanish orange. Apply mineral orange over the creases and darker areas, using touches of crimson red at the far right. For the red tulips, outline with crimson red. Lightly fill the petals with crimson red. For the dark red areas, layer with Tuscan red; for the darkest areas, layer with black. Finish the highlights by dragging red color into them and burnishing with white. To develop the greenery, use combinations of kelp green, chartreuse, canary yellow, and spring green. Add dark green and black to the darkest areas, and dark umber and bronze for the brown areas.

4 5

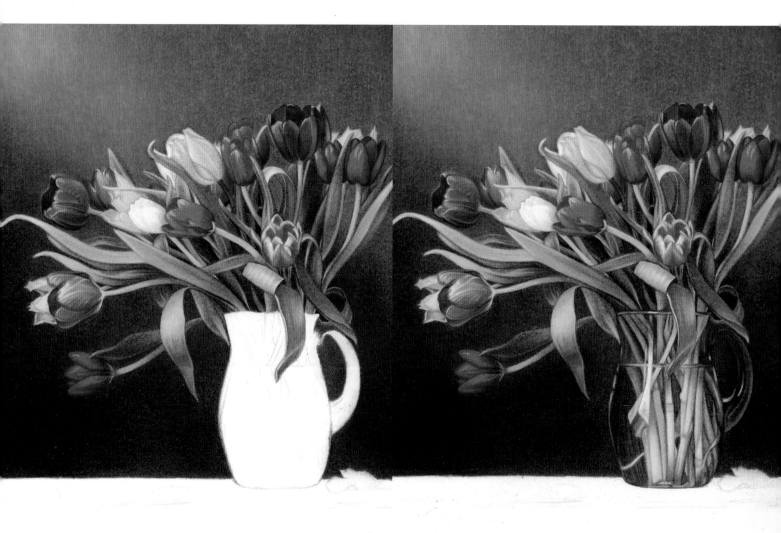

The leaf colors should contrast against the background, even if you must alter the colors and values.

4 For the purple tulip, first apply mulberry and then darken with dahlia purple, black grape, and black. Use white to lighten, soften, and pull out highlights. For the red tulips, use crimson red and Tuscan red, darkening with black and lightening with white. For the yellow tulips in the back, use canary yellow deepened with Spanish orange. On the base leaves, use kelp green, layering chartreuse and spring green for the yellow areas, and dark green for the greener areas. Apply black and dark umber for the darkest areas. Create the flower stems with canary yellow and chartreuse.

5 Draw two thin lines of kelp green to represent the rim of the vase and water line. For the lightest stems, outline with kelp green and layer with chartreuse, bronze, canary yellow, and spring green. Intensify the green areas with kelp green and moss green, using dark umber and black to darken. Use white to blend, lift highlights, and suggest reflections. For the background through the glass, use chocolate, dark umber, and black. Complete

the rim and water line with kelp green, dark green, chocolate, black, and canary yellow blended with white.

6 Use horizontal strokes of bronze and kelp green on the table top, with dark umber in the darkest areas. Blend with white and continue applying layers. For the bottom plane of the table, apply a light coat of cool gray 50% and add Kelly green, building up the darker areas with more layers and touches of dark umber. Burnish these colors with white and continue building the layers. For the purple petals, outline with mulberry and fill them in with dahlia purple and black grape. Lighten with white and darken with black. Use black for the cast shadows on the table.

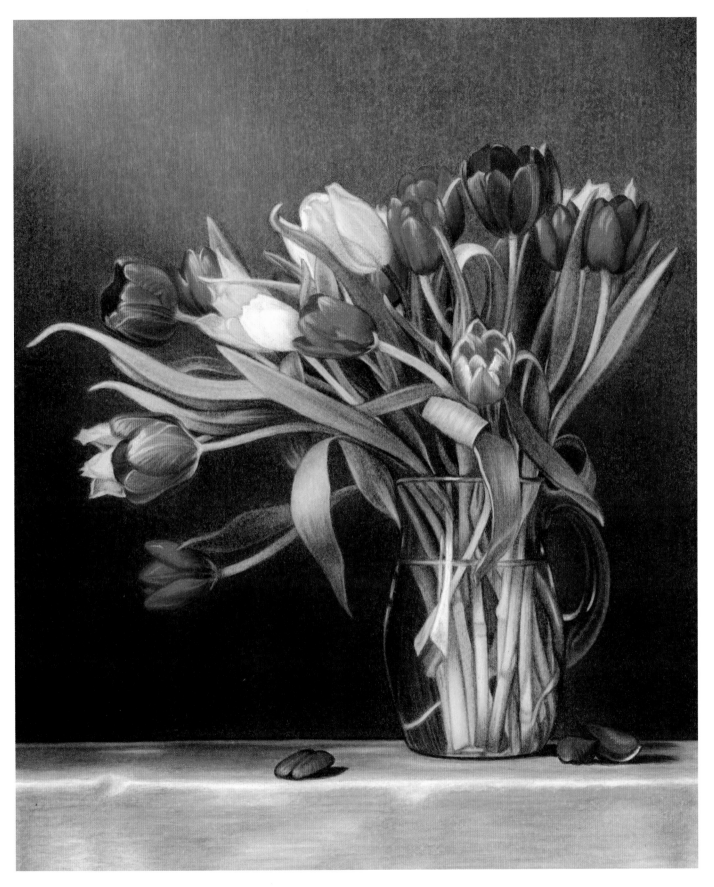

6

ACRYLIC

Daisy in Cobalt Vase

PALETTE

- Titanium white
- Cobalt blue
- Burnt umber
- Ultramarine blue
- Brilliant yellow-green
- Cadmium yellow light
- Titanium buff
- White

1

2

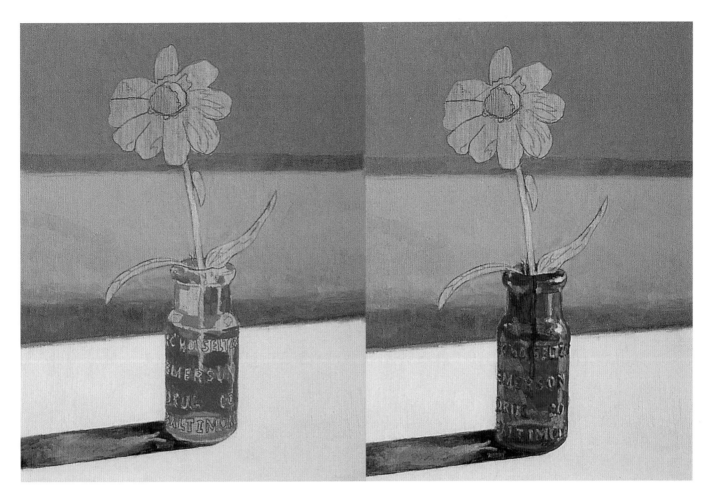

3 4

1 Use a large flat brush to evenly tone the canvas with a thin wash of ultramarine blue. Draw the composition, using a straightedge to create horizontal, sloping lines to suggest the baseboard and floor shadows. Block in the shadow of the glass bottle and apply lettering so that you'll have a guideline for your paint applications.

2 Once you are satisfied with the sketch, use a medium flat brush to block in the foreground with a mixture of titanium buff and titanium white. For the upper half of the background, mix burnt umber and ultramarine blue, adding titanium white to the mixture for the bottom half. Then create the shadows using a mix of cobalt blue, burnt umber, and titanium white, adding retarder to smooth out the transition between colors.

3 Next, build up the cast shadow near the bottle with cobalt blue, mixing in titanium white where you want to suggest that light is shining through the bottle. Begin work on the bottle itself, using a small brush to apply bold applications of ultramarine blue for the dark values and cobalt blue for the lighter ones. Paint around the lettering on the bottle, around the highlight shapes, and around the stems in the bottle.

4 Using a small round brush, create the illusion of glass by adding highlights of titanium white to the blue of the bottle. Smoothly blending these white highlights with ultramarine blue and cobalt blue gives the bottle its translucent quality. Still using the small round brush, outline areas of the lettering with cobalt blue and ultramarine blue to give them dimension and depth.

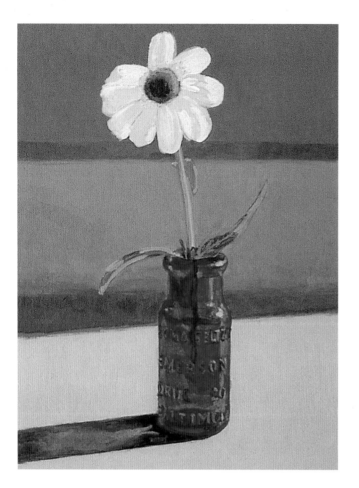

5

5 Now paint the stem of the flower using a mixture of brilliant yellow-green and cadmium yellow light. Add hints of ultramarine blue to the shadows on the leaves, and then paint the daisy's petals using cadmium yellow light mixed with titanium white. With a mix of burnt sienna, quinacridone crimson, burnt umber, and cadmium orange, create the shadow of the daisy's center. Switch to cadmium yellow medium mixed with cadmium orange and titanium white for the pollen's lightest values.

6 Finally, enhance the color of the petals, and the highlights in the daisy's center and on the bottle surface using various light mixes of the following colors: titanium white, cadmium yellow light, and ultramarine blue. Apply pink to the daisy's petals using cadmium red medium mixed with titanium white, and add the final details to the bottle using a small round brush and cobalt blue. Boost the highlights in the bottle's shadow by applying hints of titanium white to the previous layers.

PAINTING THE LETTERING As an artist, it is important to be able to give your paintings dimension and depth, as you are trying to re-create a three-dimensional object on a flat surface. After blocking in the embossed letters with white, give them depth by painting dark to light. Start with a detail brush, applying darker values of cobalt blue to outline the letters. Then, once the paint has dried, lightly dab a mixture of cobalt blue and titanium white over the letters, being careful to maintain their general shapes.

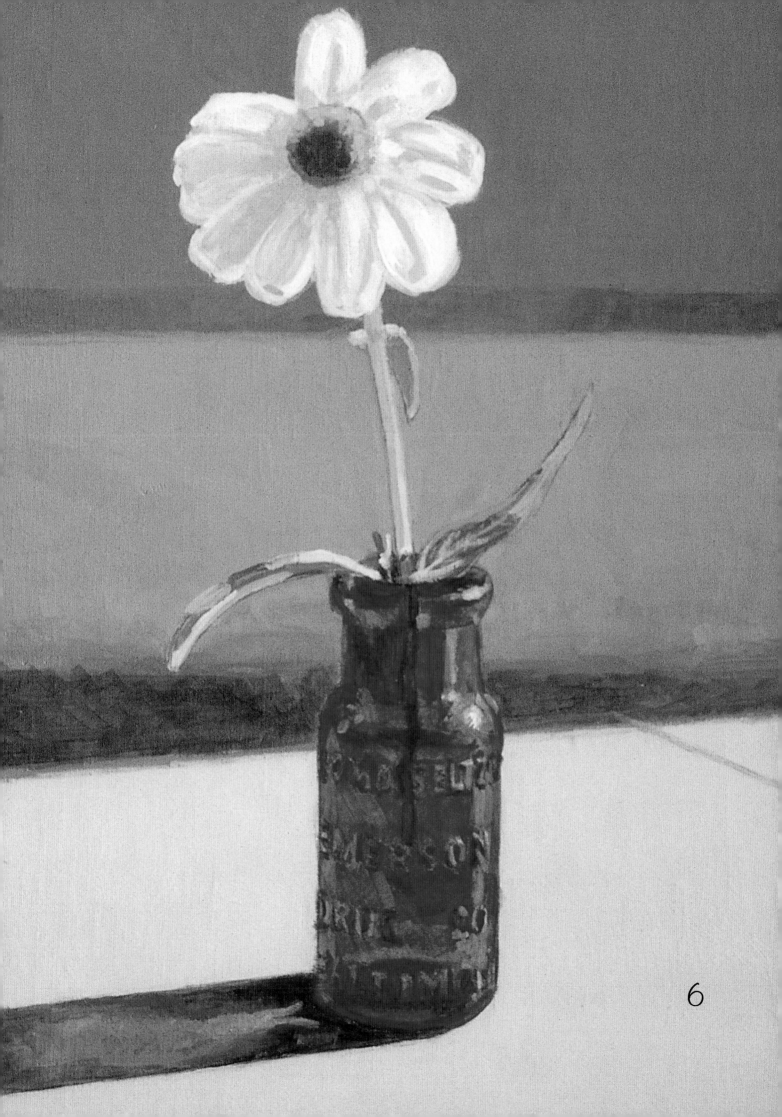

6

Red Zinnias

PALETTE

- Alizarin crimson
- Burnt sienna
- Burnt umber
- Cadmium yellow deep hue
- Hooker's green
- Payne's gray
- Permanent blue
- Raw sienna
- Raw umber
- Titanium white
- Ultramarine blue

2

1

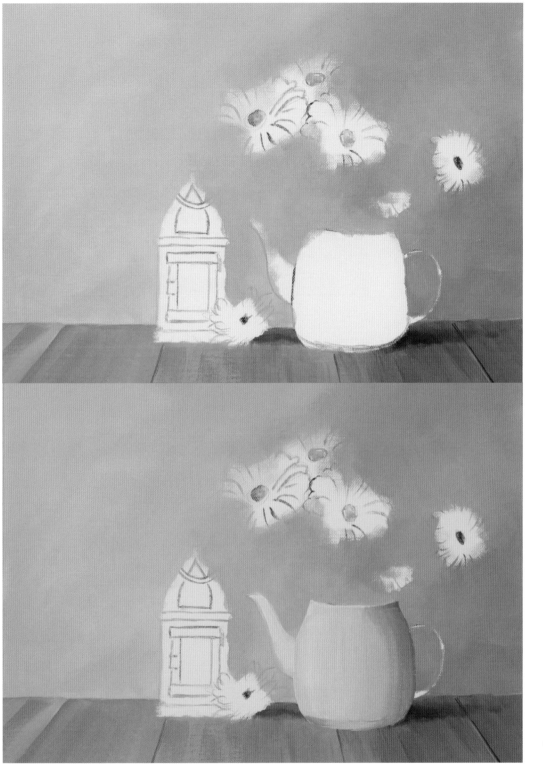

3

4

1 Draw the composition, which is the most important step for this piece. You can use a pencil or very fine lines of paint.

2 To paint the wall on the left side, use a mix of permanent blue and white. While working toward the right, reduce the amount of white and add a bit of Payne's gray to darken the wall's value.

3 To paint the table's surface, mix burnt umber, burnt sienna, and a small amount of white. Lastly, paint thin lines with pure burnt umber to indicate the spaces between the boards.

4 For this step, underpaint the teapot using white, ultramarine blue, and a bit of Payne's gray, establishing the overall values for a 3-D effect.

5 Start the flowers by painting the leaves with Hooker's green, which acts as the primary color. Then add raw umber and ultramarine blue for the shaded areas, followed by cadmium yellow for the lighter parts of the leaves and sides of the stems.

6 Start painting the white zinnias using white mixed with cadmium yellow and Payne's gray. Add more yellow and gray to the mix for the darker parts of the flowers.

7 To complete the white zinnias, paint the center of each flower with burnt umber, and touch up the petals in the light with a mixture of white and cadmium yellow.

8 To finish the teapot, add light reflections on the left side with white mixed with a small addition of cadmium yellow. Also emphasize the shadows in the vertical groves and other areas with ultramarine blue and Payne's gray.

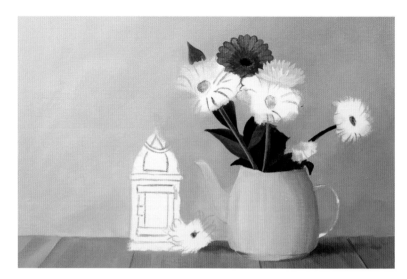

5

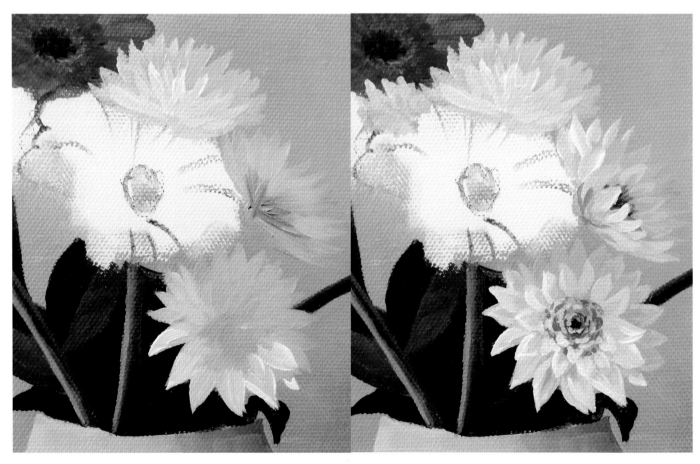

6

7

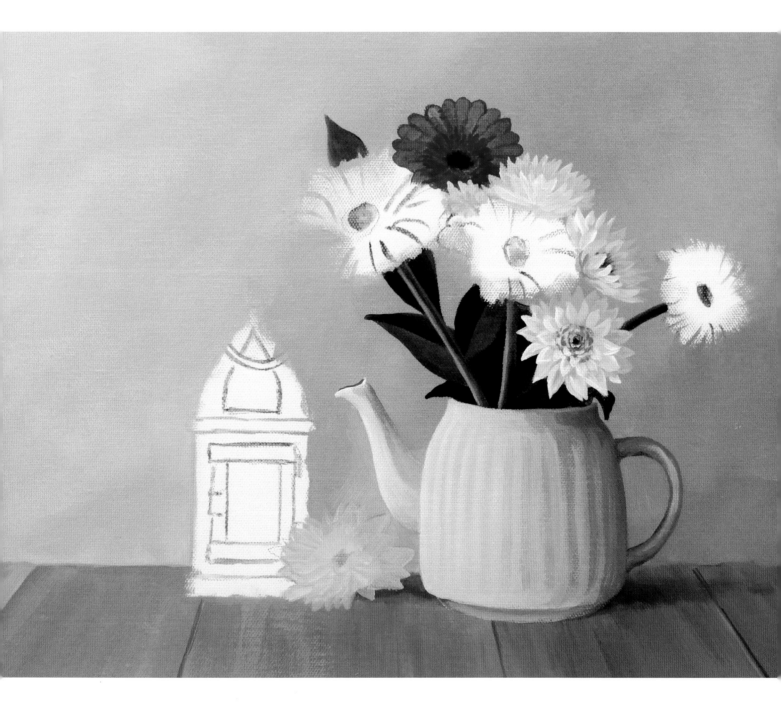

8

9 Using alizarin crimson, paint the circles to represent red zinnia petals. Use Payne's gray for the centers of the flowers.

10 Finish the outline of the flowers and place the petals with a ¼-inch round brush.

11 Next add white to the alizarin crimson and paint over the petals to show reflections of light.

12 To complete the flowers, paint small petals in each center using a small round brush. Use a mixture of alizarin crimson and Payne's gray for the petals in shadow, followed by a mixture of alizarin crimson and white for petals in light. Leave the dark center of each flower untouched.

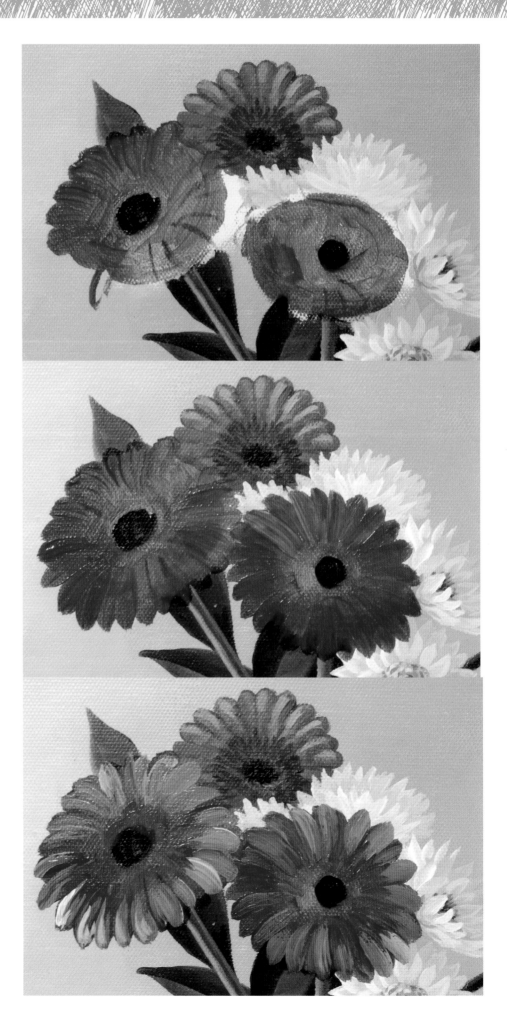

12

Rose in Clear Vase

1

PALETTE

- Burnt sienna
- Burnt umber
- Cadmium red light hue
- Cadmium yellow medium
- Naphthol crimson
- Sap green

- Titanium white
- Ultramarine blue

OPTIONAL
- Polymer gloss medium

2

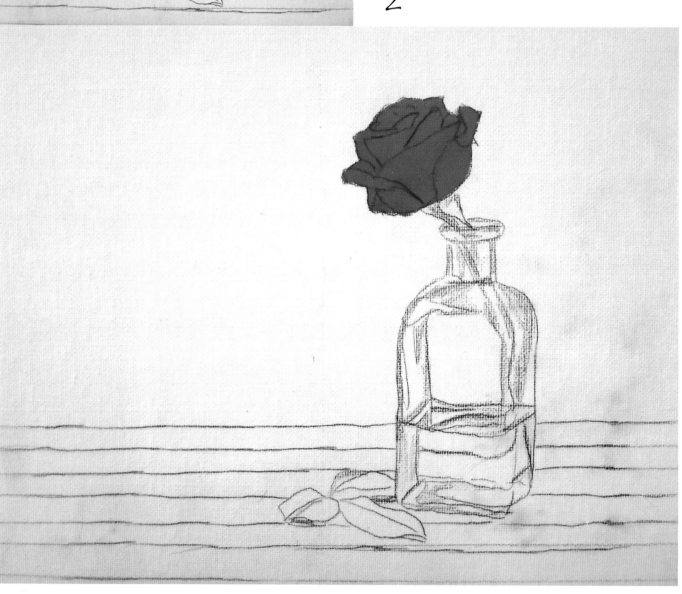

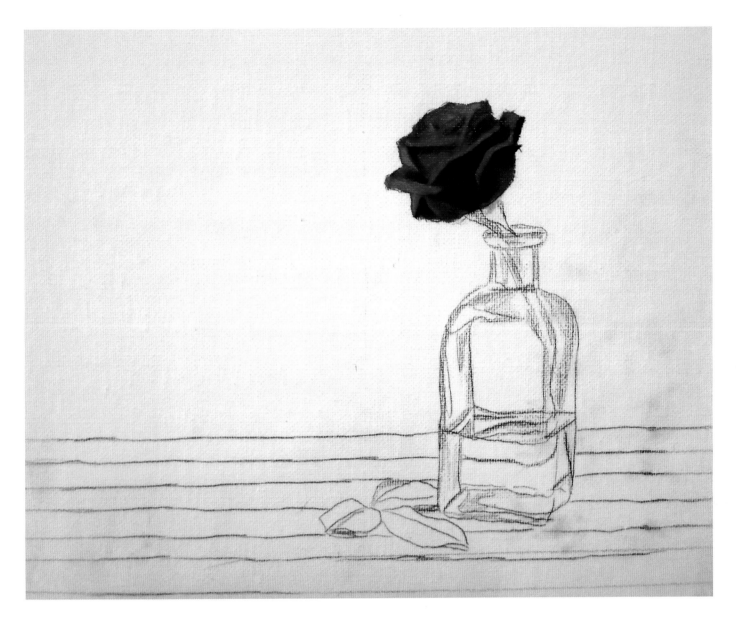

3

1 Sketch the composition directly onto an 8" x 10" canvas with a soft lead pencil or watercolor pencil.

2 Use a watercolor pencil to lightly shade the darkest values. Then make a thin mix of cadmium red and naphthol crimson to block in the rose; this color serves as the rose's middle value. These pigments are transparent, so you can still see the pencil lines underneath.

3 Mix a dark-value rose color with ultramarine blue and a bit of burnt umber, and apply the darkest parts to the rose. Blend harsh lines gently with a soft brush before the paint dries. Since the tops of the rolled edges on the rose appear lighter, paint these with a mix of naphthol crimson and a little cadmium yellow medium.

4. Paint the darkest values of the stem first with sap green. Then model the rest of the stem by mixing sap green with cadmium yellow medium to lighten areas as needed. Gently smooth the brush marks and transition areas with a soft, damp brush. Paint the background with a mixture of ultramarine blue, cadmium red light hue, burnt umber, and titanium white. Use a soft brush with a bit of water to lay in the color behind the bottle and the background. Remember that the bottle is transparent but it will still block some of the light, making the background behind it appear darker.

5 Add ultramarine blue and titanium white to the green mix from step 4 to create lighter green values for the bottom of the bottle. Paint the leaves on the table with sap green and add cadmium yellow medium to lighten the color where needed. Use burnt umber to paint the small shadows under the leaves, and the lines on the table. When the lines are dry, paint the tabletop with a very thin mixture of burnt sienna and titanium white, using a soft flat brush.

6 Examine the canvas to see where colors or values need to be adjusted. You may have lost some of the green in the bottle when you painted the background, so glaze a very thin layer of sap green mixed with ultramarine blue and titanium white over the body of the bottle. Paint a thin glaze of burnt umber on the table for the bottle's shadow and darken the shadow along the front of the table. When the painting is dry, cover it in a thin layer of polymer gloss medium thinned with water.

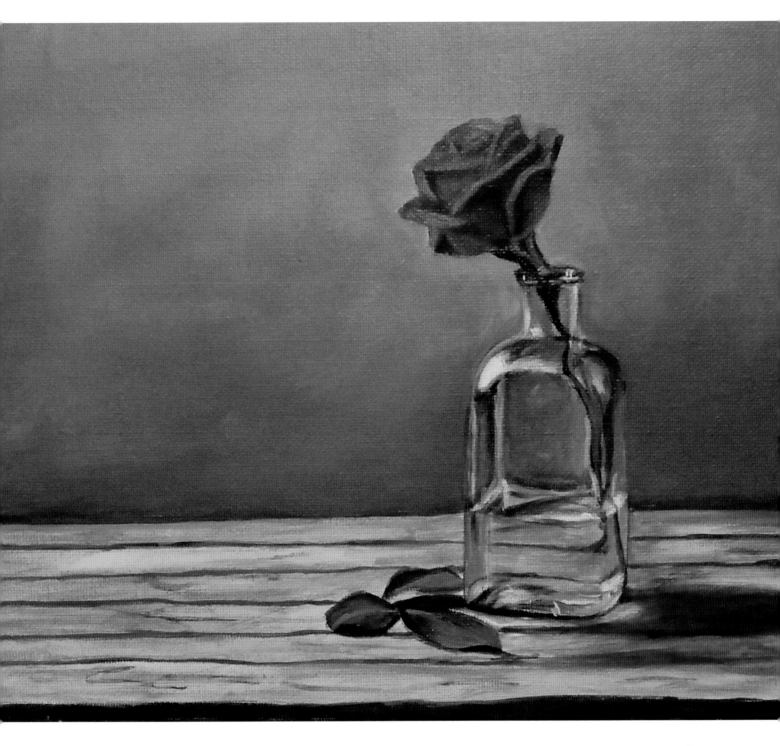

6

Poppies

PALETTE

- Burnt umber
- Burnt sienna
- Cadmium red light
- Cadmium yellow medium
- Dioxazine purple
- Hooker's green
- Naphthol crimson
- Titanium white
- Ultramarine blue
- Yellow oxide

OPTIONAL

- acrylic glazing medium, polymer gloss medium

1 Lightly sketch the flowers and tabletop on a white canvas. You can draw the value changes in the flowers, which will be helpful when you start to apply paint. Don't draw the stems and buds, as they will be covered by the first layer of paint.

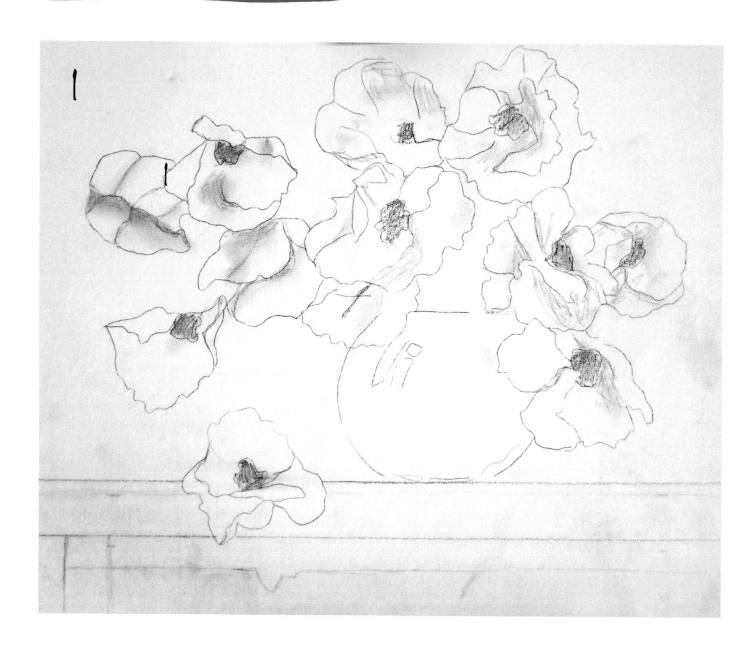

2

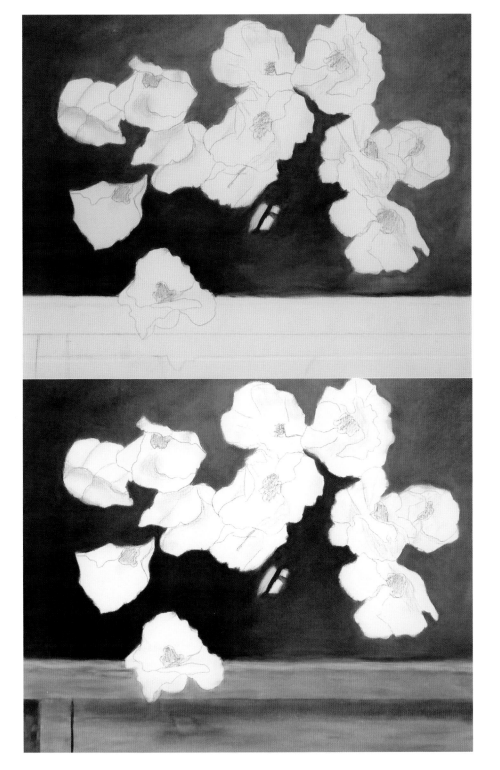

3

The first layer of paint will be fairly transparent. Continue painting the background until you are happy with the coverage, color, and texture. Just remember to let each layer dry completely before starting another. Use water to thin the paint as needed.

2 Mix burnt umber and ultramarine blue with a bit of yellow oxide for a rich, dark olive green. Paint the darkest side of the background with this mix, using a #6 flat brush to carefully paint around the flowers. For the lighter side of the background, mix yellow oxide with a tiny bit of the dark mixture. Use a soft angle brush to smooth the transitions between the two colors and to eliminate brush marks. Allow this layer to dry before painting a few more layers to develop an opaque, smooth, and cohesive background.

3 Next, mix a thin puddle of paint for the tabletop, using equal parts yellow oxide and burnt sienna. Use a flat wash brush to paint a very thin layer over the entire table. Before the paint dries completely, gently scrub out some of the paint on the top edge of the table where the light makes it appear lighter in value. Allow the area to dry; then paint the shadows under the tabletop edge and under the flower on the table with thinned burnt umber.

4 Use a mixture of cadmium red light and naphthol crimson to block in each flower. This first mixture is the middle value. For the darkest values on the flowers, mix cadmium red light with dioxazine purple and follow the underlying sketch as a reference. Use a soft brush to blend transitions between colors. For the lightest values, add a little titanium white to cadmium red light. Mix burnt umber and ultramarine blue for the centers.

5 Using Hooker's green and cadmium yellow medium, begin to paint the stems. In the area within the glass bowl, mix a little burnt umber into Hooker's green for a darker value. Use cadmium yellow medium on the highlighted sides of the stems.

6 Paint a few buds with cadmium red light mixed with burnt umber in the darker areas. Re-establish the glass bowl by using a watercolor pencil to lightly draw it on the canvas. Continue glazing layers over the canvas until you have rich, deep color throughout the painting. Finish by cleaning up the edges. When the painting is completely dry, mix polymer gloss medium with a little water and apply a thin layer to give nice shine and brilliance to the colors.

4

5

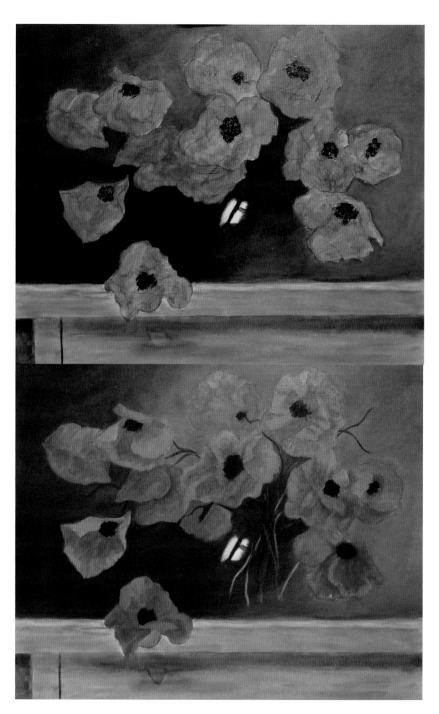

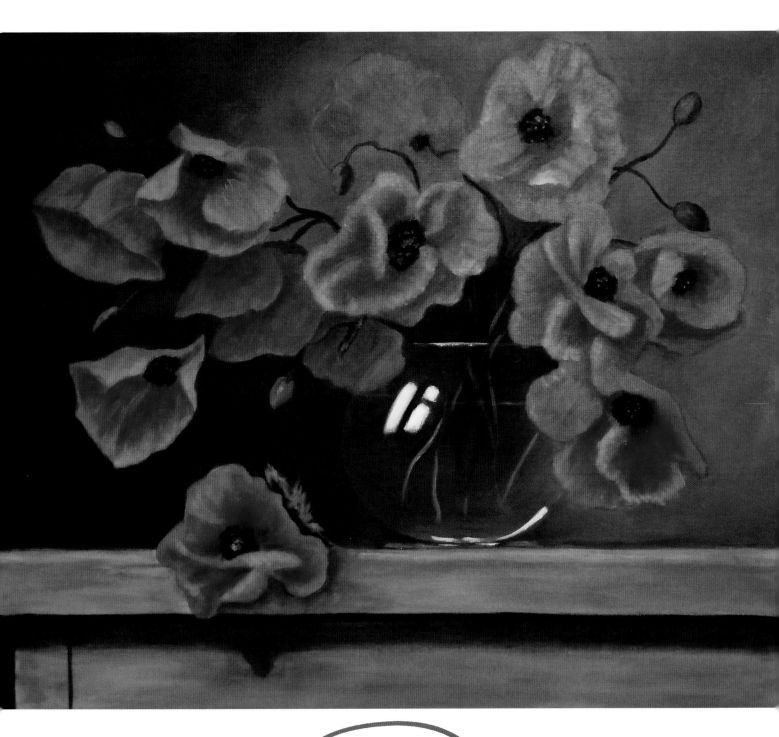

6

To create the look of transparent glass, mix a tiny amount of titanium white into a quarter-sized dollop of glazing medium and use a soft angle brush to paint the inside of the bowl. You should see a filmy white glaze on the canvas that gives the illusion of looking through glass.

Tulips

1 Make a quick sketch with pine gray on a canvas. Approach your underpainting in parts, beginning with the darkest values. With a ¼-inch flat brush, paint the leaves using sap green. In the lighter areas, Add a little cadmium yellow medium to the green. In more shaded portions, mix in ultramarine blue instead.

PALETTE

- Alizarin crimson
- Burnt sienna
- Cadmium red medium
- Cadmium yellow medium
- Pine gray
- Sap green
- Titanium white
- Ultramarine blue
- Yellow ochre

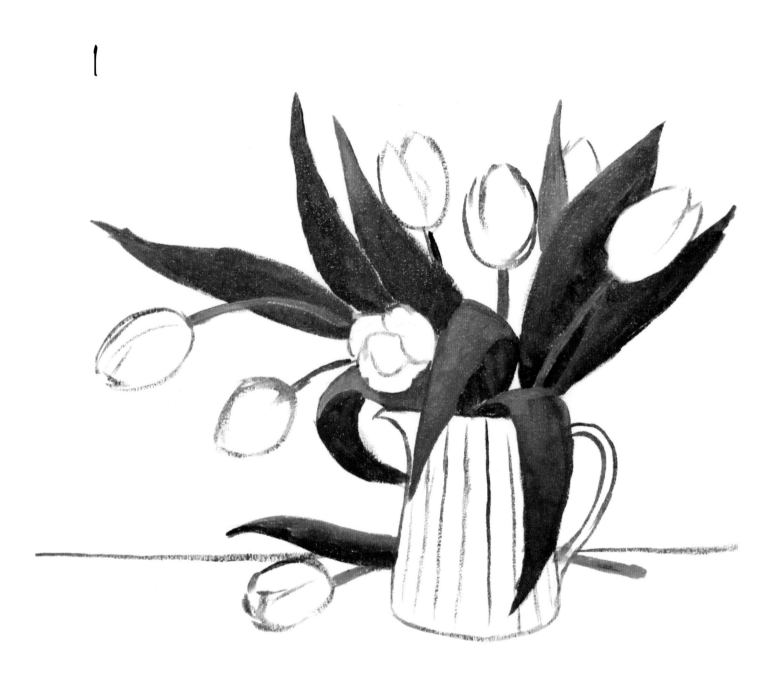

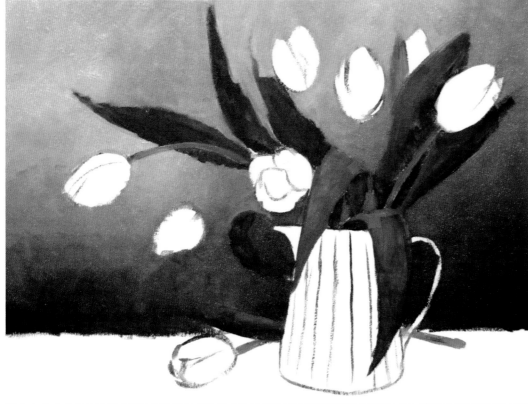

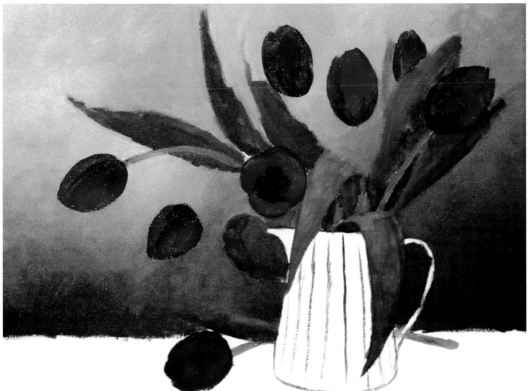

2 Starting at the top of the canvas with the background, begin with a warmer tone, mixing yellow ochre and burnt sienna. Eliminate the yellow ochre and gradually add ultramarine blue to the mix as you move down toward the table.

3 For the first layer of tulip color, apply alizarin crimson mixed with cadmium red medium for the lighter areas. As you move toward the shadowed areas, add ultramarine blue for the darker tones.

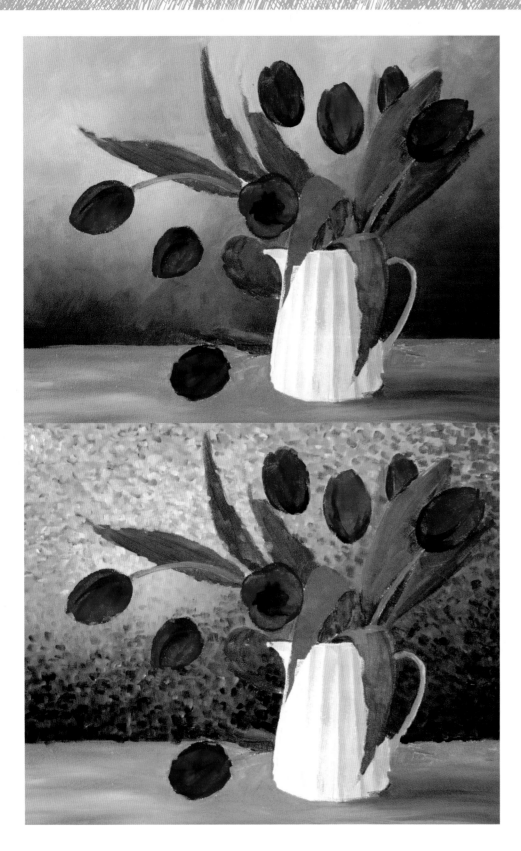

4

5

4 Paint the table with a coat of yellow ochre and burnt sienna, with ultramarine blue mixed in for the shadow. The vase is mostly white, but mix cadmium yellow medium with titanium white for the light side, and alizarin crimson and ultramarine blue for the shadowed side.

5 At this stage, add more strokes of any color or colors that you think might benefit the overall painting; adding a few strokes of sap green and other colors help reflect the tulips.

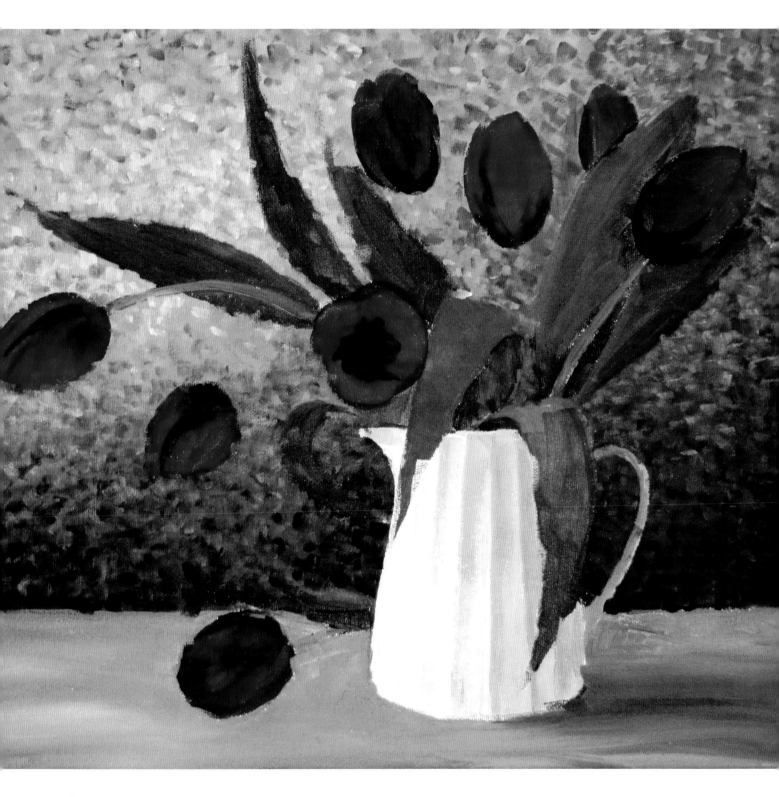

6

6 Stroke in more of the warm colors along the entire bottom of the wall and add more dark color into the transition zone. Refine any details as needed.

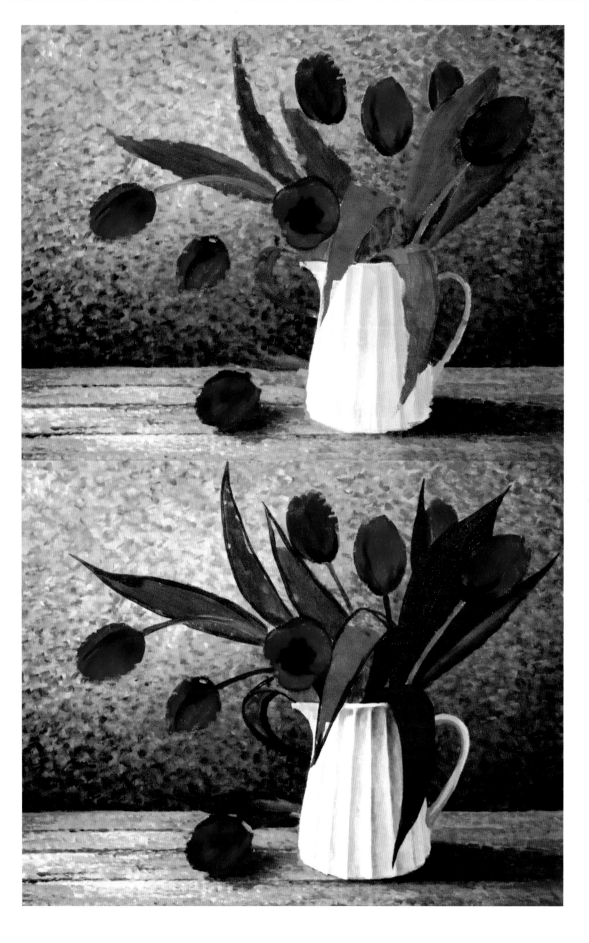

7

8

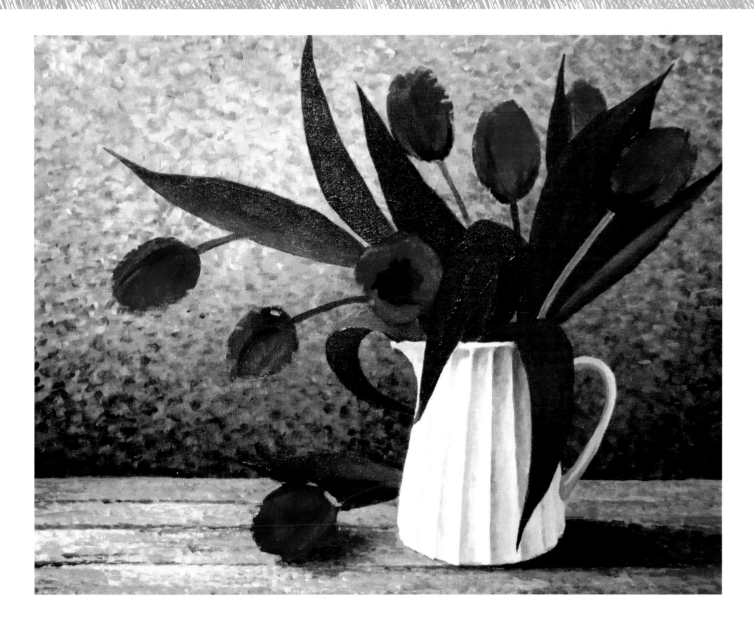

9

7 Paint the tabletop with the same cool colors from the wall: alizarin crimson, ultramarine blue, and titanium white. Use the darker, cooler colors as well, but apply the pine gray, ultramarine blue, and white only in the shadows cast by the tulip and vase.

8 Redefine the edges of the leaves with more sap green. Shift focus to develop the vase (see detail).

9 Mix sap green and ultramarine blue and paint the shaded parts of the leaves and stems with a ¼-inch flat brush.

DETAIL Paint the grooves of the vase using cadmium yellow medium mixed with titanium white on the light side of each groove, and alizarin crimson, ultramarine blue, and burnt sienna on the shadow side. The lighter parts also reflect a little blue from a secondary light source.

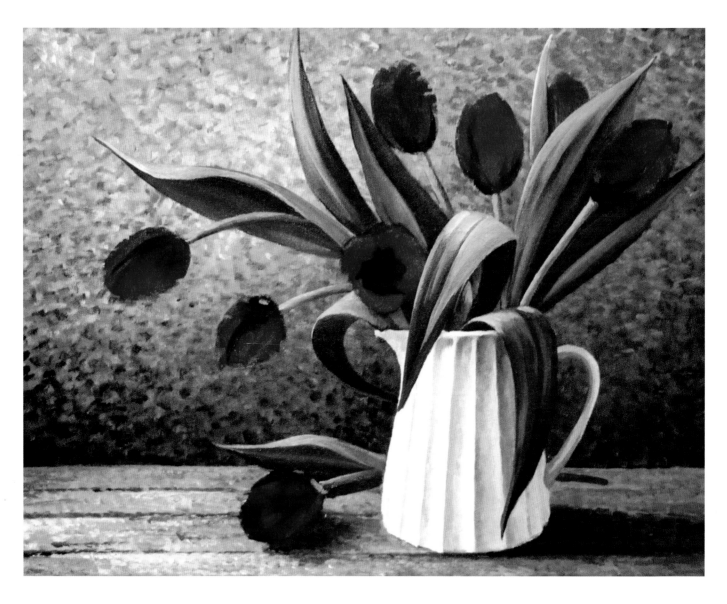

10

DETAIL The tulips are the focal point of this painting, so attention to detail is important. Be especially mindful of the direction of the light source when applying the highlights.

10 Now bring out more detail in the stems and leaves by adding lighter portions with a mix of cadmium yellow medium, titanium white, and sap green.

11 Everything is complete now except for the flowers. Cover the underpainting with a dark layer of alizarin crimson mixed with ultramarine blue to establish the shadows. Then apply cadmium red medium on the petals to create a transparent effect. Finish with the highlights, using a mixture of cadmium yellow medium and titanium white.

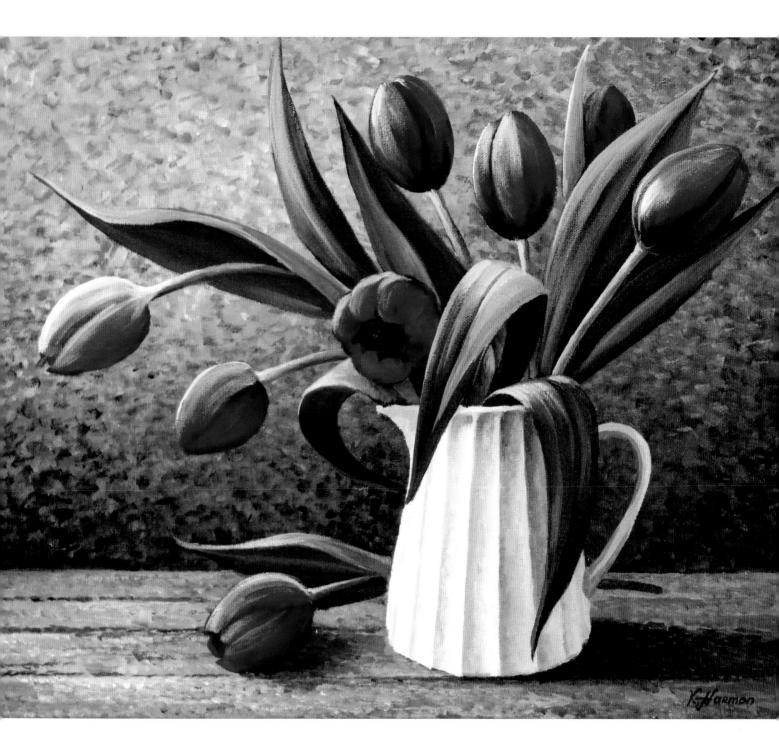

11

ACRYLIC

Magnolia

PALETTE

- Alizarin crimson
- Burnt sienna
- Cadmium yellow deep hue
- Sap green
- Titanium white
- Ultramarine blue
- Winsor lemon

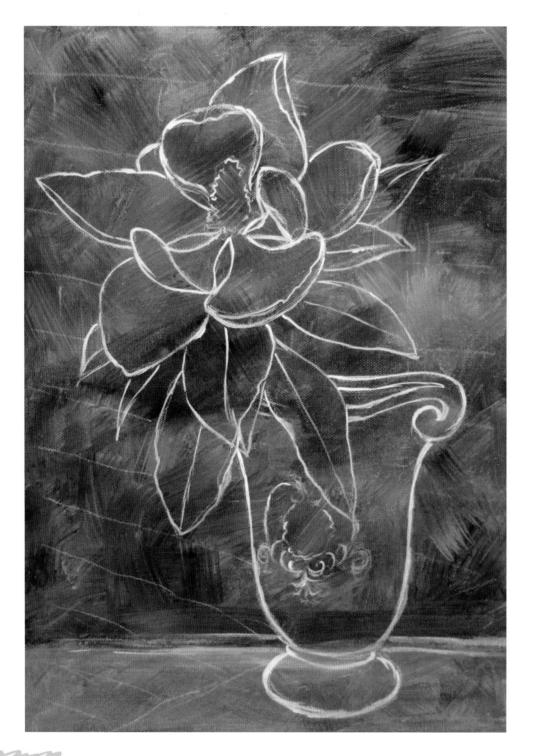

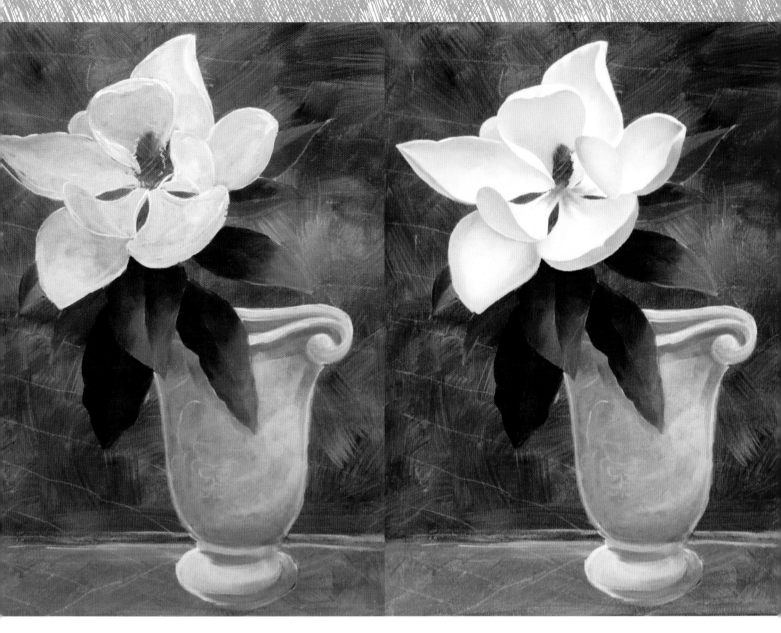

2

3

1 Using a 1-inch-wide flat brush, paint the background with a thin layer of burnt sienna mixed with ultramarine blue. Then draw the magnolia and vase with a white pencil. White shows the lines more clearly, but any color appropriate for the painting will work.

2 Continue the underpainting by filling in your drawing of the magnolia flower with titanium white and adding a bit of ultramarine blue for the shaded area of the petals. For the leaves, use sap green and add cadmium yellow to paint the lighter areas. The vase color is a mixture of titanium white, ultramarine blue, and a touch of burnt sienna.

3 Next focus on the details of the magnolia flower using primarily titanium white with the addition of a little Winsor lemon in the lighter areas. To suggest the shaded area of the petals, add ultramarine blue mixed with a hint of alizarin crimson. There is a slight reflection of yellow-green on the side of some petals facing the leaves. Re-create these reflections by adding a small amount of sap green and cadmium yellow to titanium white.

Underpaintings help establish the most important elements of the artwork: composition, value, and color theme. Make sure the first two steps are painted with a very thin layer of paint.

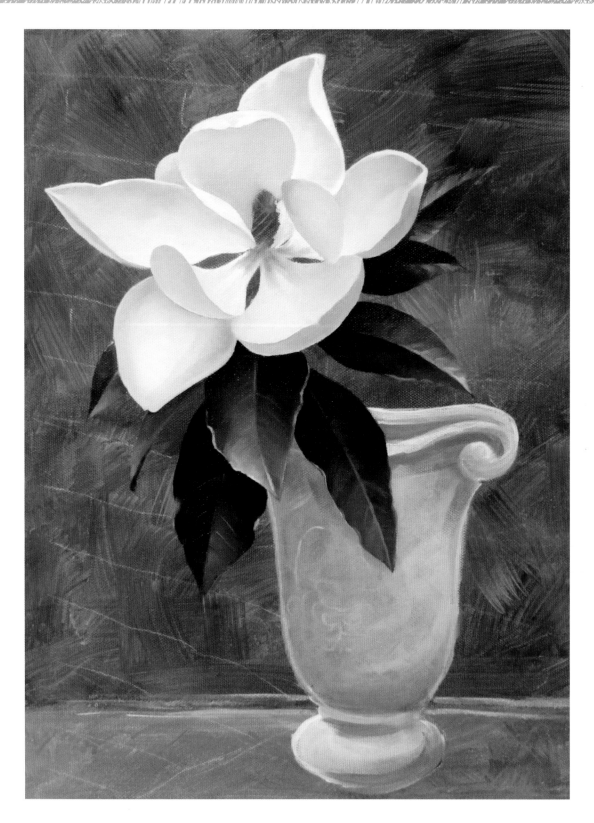

4

4 Paint the shaded areas of the leaves with a mixture of sap green, ultramarine blue, and a small amount of burnt sienna. As you work toward the lighter area, add more cadmium yellow. For the lightest areas of the leaves, add Winsor lemon mixed with titanium white. Apply your final touches after you finish the background wall.

5

A

B

C

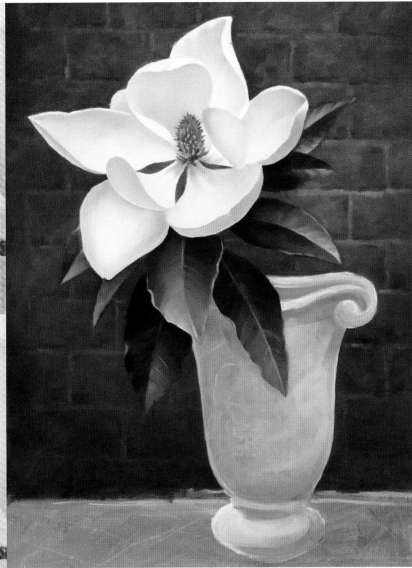

6

5 Paint the stamen—the center part of the flower—in three short steps.

 A First paint the base shape of the stamen with a mixture of burnt sienna, sap green, and cadmium yellow.

 B Then use Winsor lemon to paint the carpals on the center of the stamen.

 C As a finishing touch, add darker strokes along the outline of the stamen using sap green and burnt sienna.

6 Moving to the background, paint the brick wall using ultramarine blue, burnt sienna, and alizarin crimson, along with a tiny bit of titanium white. Do not mix these paints evenly in order to produce the interesting "patchy" effect on the wall. Next add some detail to the bricks, including the mortar lines along the tops and sides, by mixing more white into the blend. Paint a darker line along the bottom of the bricks to make them appear three-dimensional.

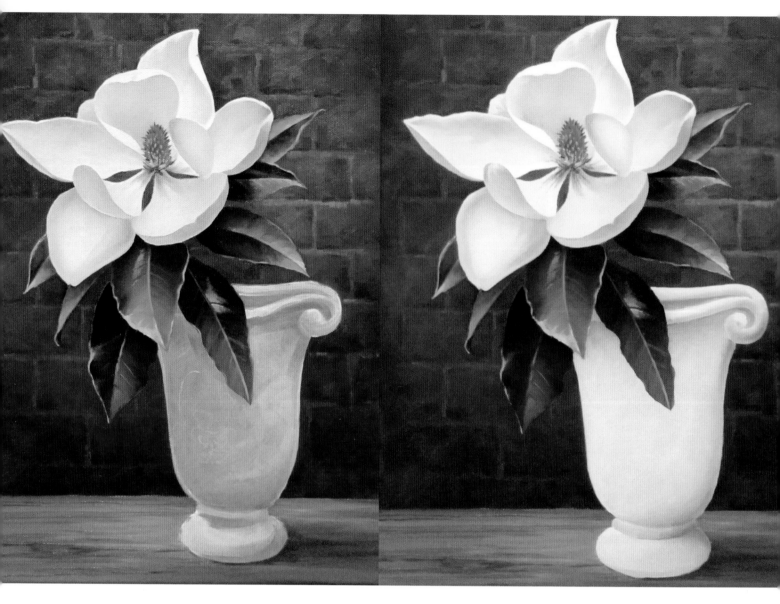

7

8

7 Mix ultramarine blue, titanium white, and some burnt sienna to paint the weathered surface of the wood railing. To create the textured part of the wood, including the knots and cracks, use less white paint in your mixture and apply it with the side edge of a flat brush. Also place some additional touches on the leaves to show more reflections.

8 Create the porcelain effect of the vase using a mixture of white, ultramarine blue, cadmium yellow, alizarin crimson, and a little bit of burnt sienna. Add a touch of sap green on the sides of the vase's rim and near the top, to show the reflections from the leaves.

9 For the final touch, paint design details on the vase. Use a combination of white and cadmium yellow for the light sections of the design detail. For the midtone areas, add alizarin crimson to the mixture. Lastly, use a cool combination of ultramarine blue and white in the shaded areas.

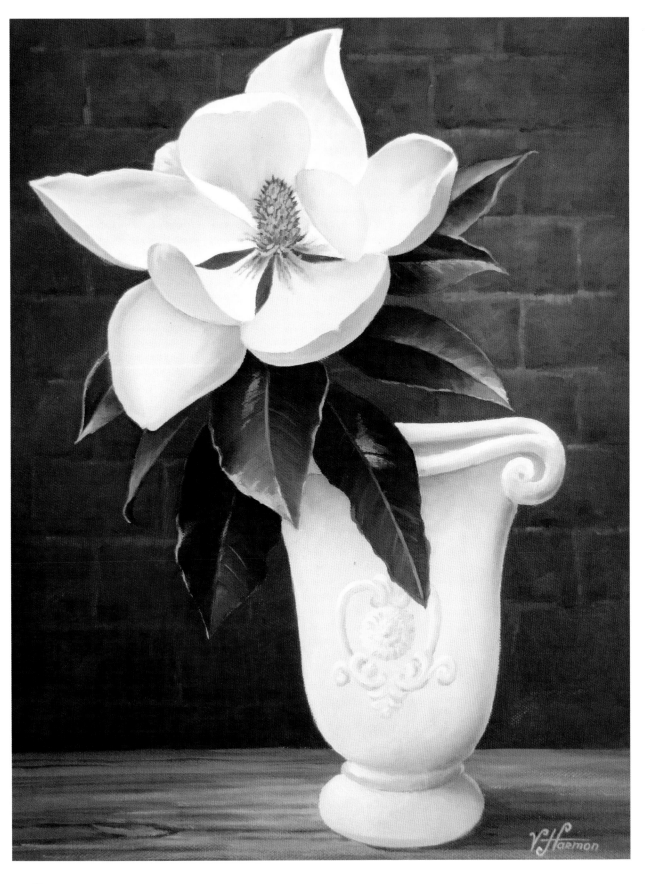

9

CHAPTER 5
OIL

Fuchsia

1 Begin by mixing one part liquin and one part turpentine in a glass jar, and set aside a small amount in another lidded jar to use later. This is known as a "medium mixture." To tone the canvas, mix a quarter-size dollop of the medium mixture with an equal size dollop of sap green using a palette knife or large flat brush until you have a transparent hue. (It may be necessary to keep adding medium until the paint becomes transparent.) Apply the mixture to the entire canvas in loose, quick strokes, emphasizing the areas of foliage.

2 Next mix a small dollop of medium with phthalo red rose until you have a transparent hue. Continue the underpainting by applying the mixture with a broad flat brush and loose strokes across the areas of the canvas that will be the fuchsia blossoms. To lighten areas of paint, brush on clear liquin using a broad flat brush. The underpainting creates a wet surface for the steps that follow.

PALETTE

- Crimson
- Phthalo red rose
- Phthalo violet
- Quinacridone rose
- Sap green
- Titanium white
- Yellow green

OIL PASTELS
- Kelly green
- Red rose
- Violet or purple

MEDIUM
- One part liquin + one part turpentine

1

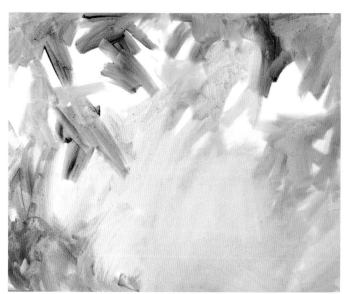

2

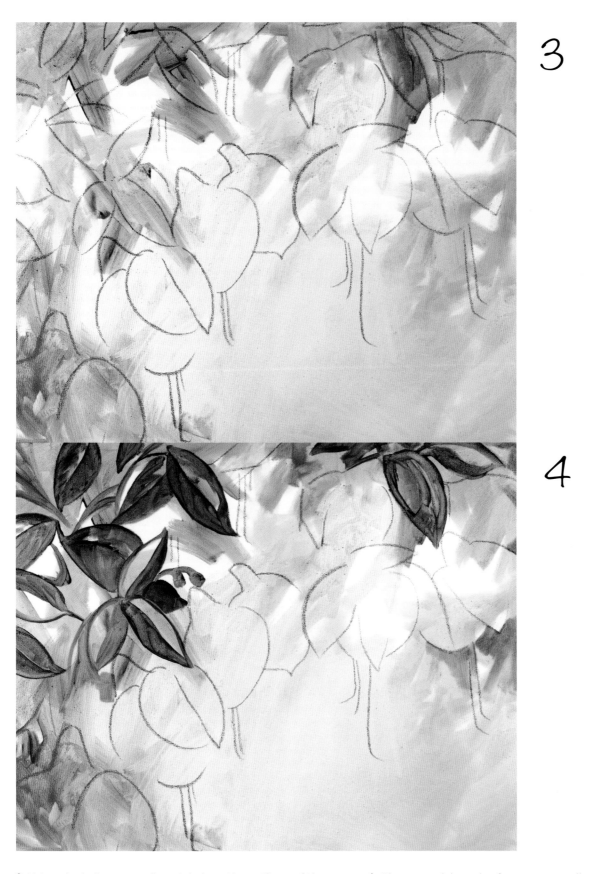

3

4

3 Using the kelly green oil pastel, draw the outlines of the leaves in thin, continuous lines. Do the same using the red rose oil pastel or phthalo red rose paint for the fuchsia blossoms.

4 Place one dab each of sap green, yellow green, and titanium white on the palette. Load a small flat brush with the medium mixture from Step 1, and a bit of sap green to begin painting in the leaves. Follow this same process with the yellow green and titanium white, always working from darkest to lightest.

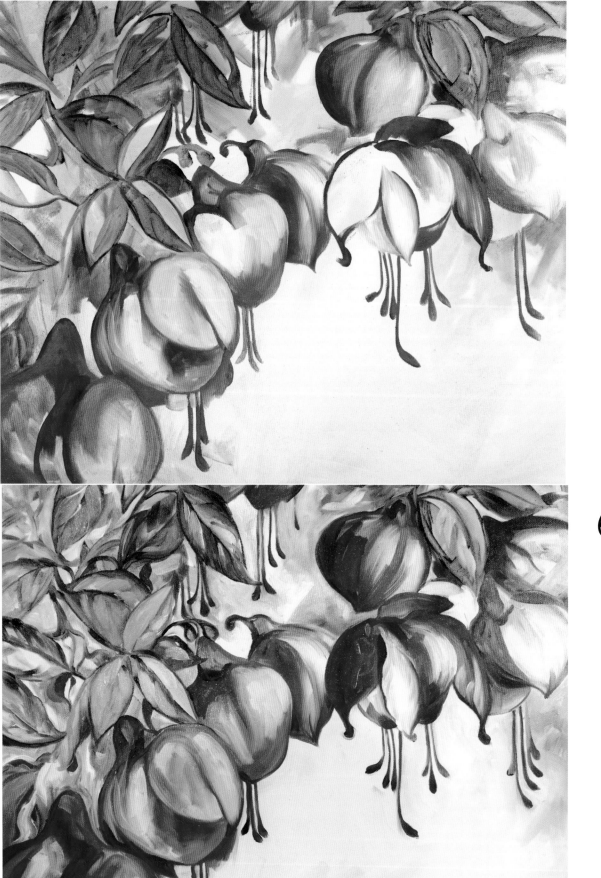

5

6

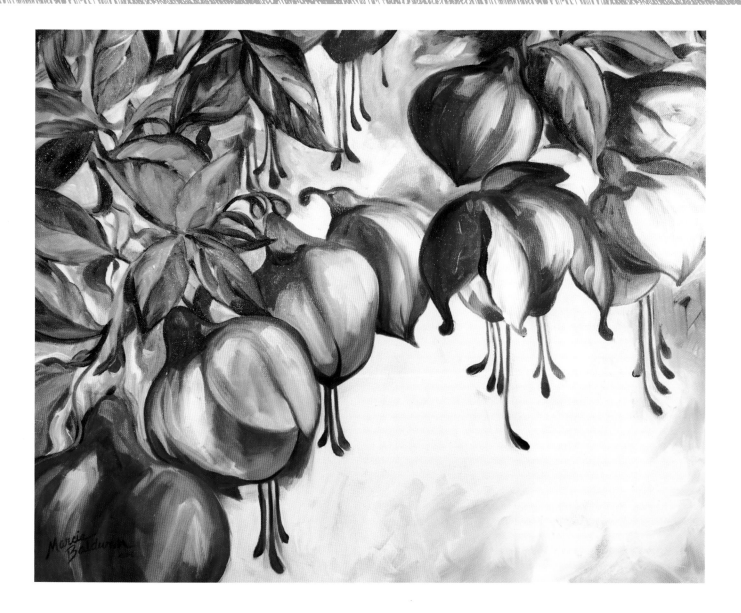

7

5 Place one dab each of quinacridone rose, crimson, phthalo violet, and titanium white on the palette. Following the directions from Step 4, begin filling in the fuchsia blossoms, again working from darkest to lightest. Make sure to clean your brushes each time before changing colors.

6 With the primary shapes established, further define and sharpen the leaves and blossoms, and blend and soften areas of less focal interest. To sharpen edges, use the side of a soft, flat brush, loaded with paint and less medium than in previous steps. Then use a soft flat brush to gently blend and soften edges that move away from the central focal point. Finally, use titanium white and flat, bold strokes to add highlights where needed.

7 Add a bit of titanium white to sharpen some of the blossom edges to give them a clean finish. Use some titanium white to soften the edges around the foliage.

Using less medium mixture when applying the oil paints will create a thicker, more opaque layer in areas where you want more detail.

Peonies

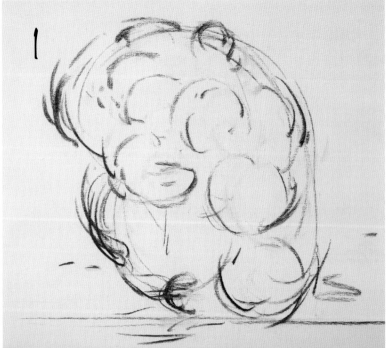

PALETTE

- Titanium white
- Cadmium lemon yellow
- Cadmium yellow light
- Cadmium orange
- Yellow ochre
- Cadmium red light
- Cadmium red medium
- Alizarin crimson
- Cobalt blue
- Ultramarine blue
- Phthalo blue
- Raw umber
- Ivory black
- Phthalo green

OPTIONAL
- Burnt sienna
- Magenta

MEDIUM
- one part linseed oil + one part damar varnish + one part English distilled turpentine

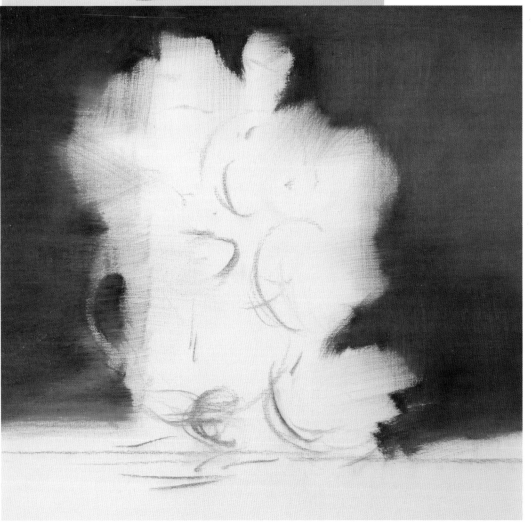

1 Tone a canvas with thinned cadmium red medium. Then loosely sketch the subject in soft vine charcoal.

2 Using a #2 white bristle brush, apply raw umber thinned with oil medium. Brush off any charcoal with a 1-inch soft bristle brush and paint the background with a mixture of burnt sienna and phthalo green. A 2-inch brush is ideal for painting backgrounds.

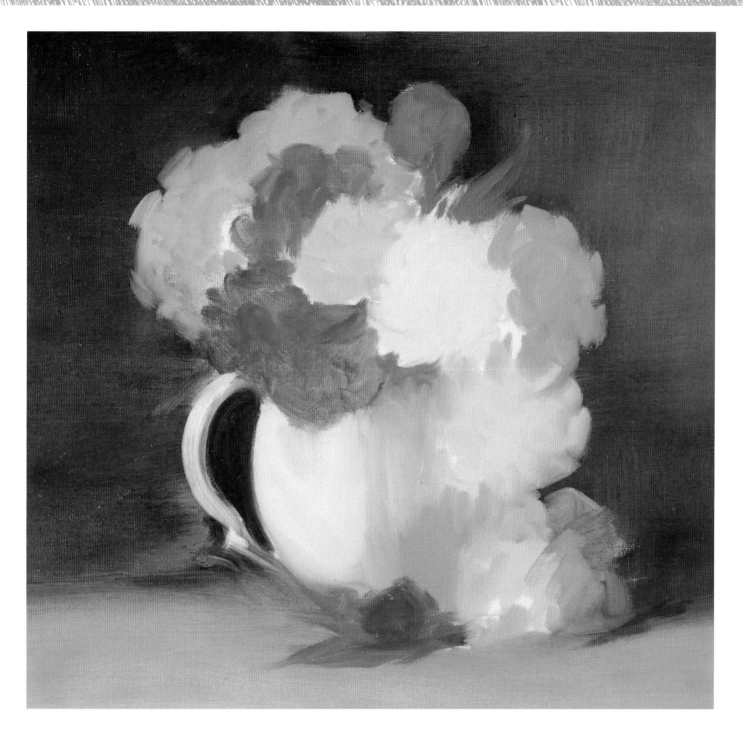

3

As you sketch the peonies, keep in mind their spherical shape. Remember to reduce an object to its simplest shape, whether a sphere, egg, cylinder, or cube.

3 Block in the local colors with flat middle values. For the white peony, mix ivory, black, and white to make gray. For the pink peonies, use a mixture of alizarin crimson and gray. And for the red peonies, use cadmium red medium. Add magenta to the alizarin crimson in the foreground flower. The vase is simply gray and the table is blocked in with yellow ochre.

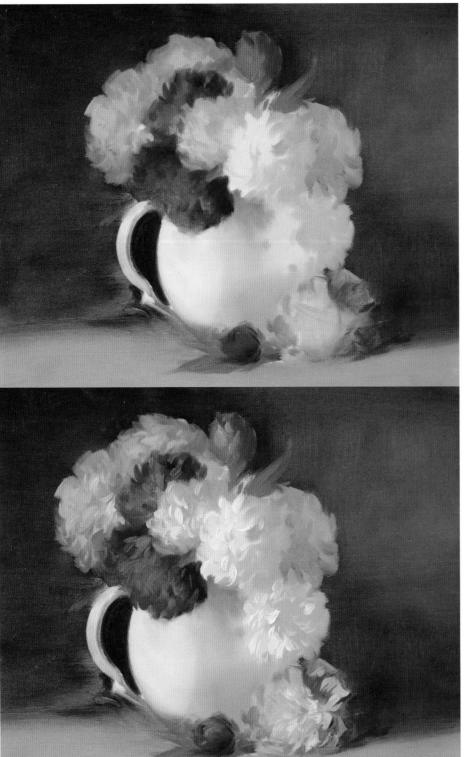

4

5

4 Begin to add the darker values of the shadows on the flowers. Use a darker-value gray for the white peony. For the pink peony, use a darker pink made with alizarin crimson and a darker gray. The dark red is a mixture of alizarin crimson and cadmium red medium. Notice how the form of the objects is starting to develop.

5 Next build the light in the painting, beginning with your lightest light; the white peony on the right of the bouquet in the composition. Use a #6 sable brush loaded with titanium white and a tiny bit of cadmium lemon yellow to "draw" each petal as it relates to the larger spherical form. Moving away from the white flower, treat the pinks and reds in the same way. Use pure cadmium red light for the lights on the red peonies.

6 To further develop and sharpen the forms, intensify some darks in the shadow areas. Then develop the leaves, defining them with a #6 sable brush. Develop the form of the vase.

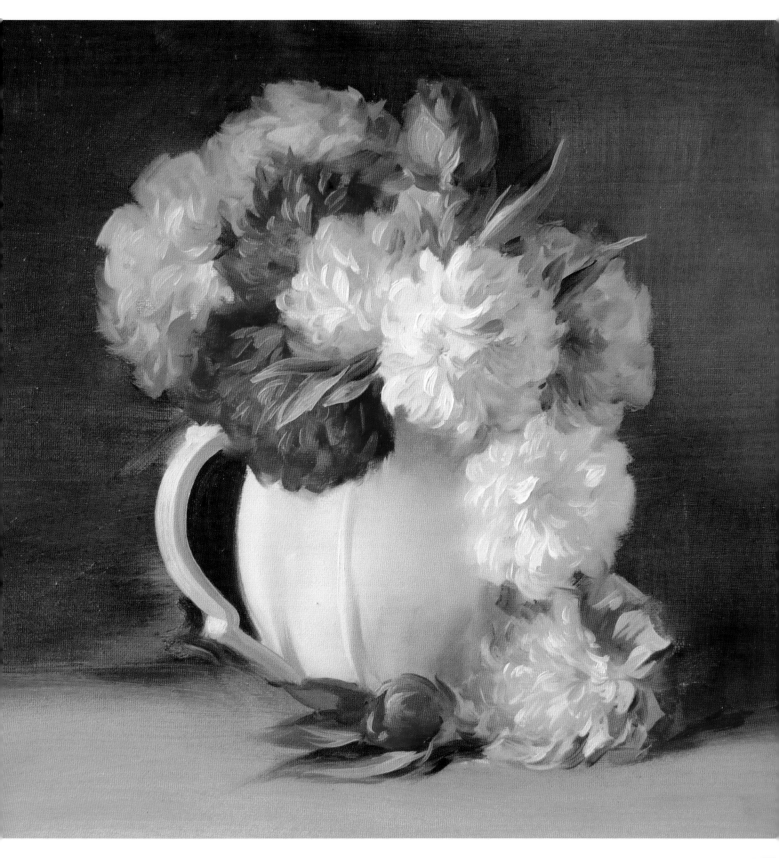

6

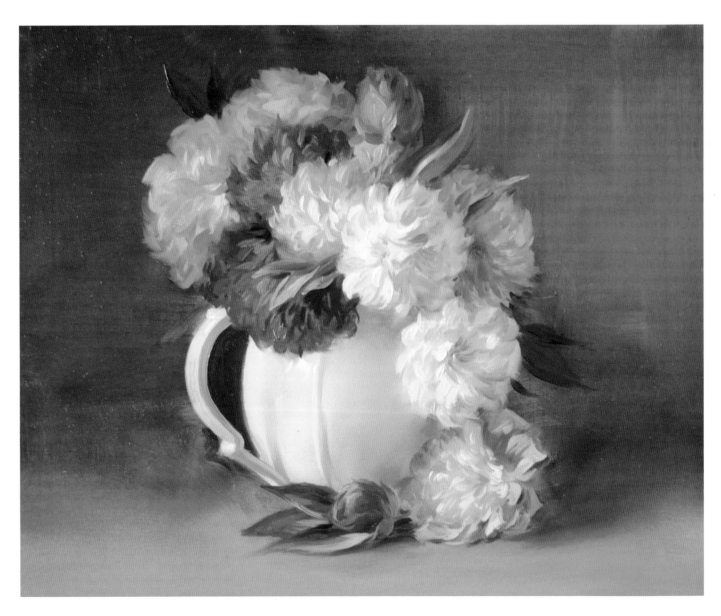

7

7 Add more leaves to emphasize the movement and rhythm of the floral composition.

8 At this stage, whatever you do, do for the "sake of the painting." In this case, add fallen petals to the table. Then darken the table on the left with a mixture of yellow ochre and raw umber to increase the focus of the painting. Continue refining the flower petals with a #2 sable brush. Add gray halftones on the table to create an atmospheric transition from the warm light into the warm shadow. Finally, add a pure white highlight on the porcelain vase.

A simple mixture for the green leaves is lemon yellow, ivory black, and ultramarine blue. For a lighter green, add more yellow and white.

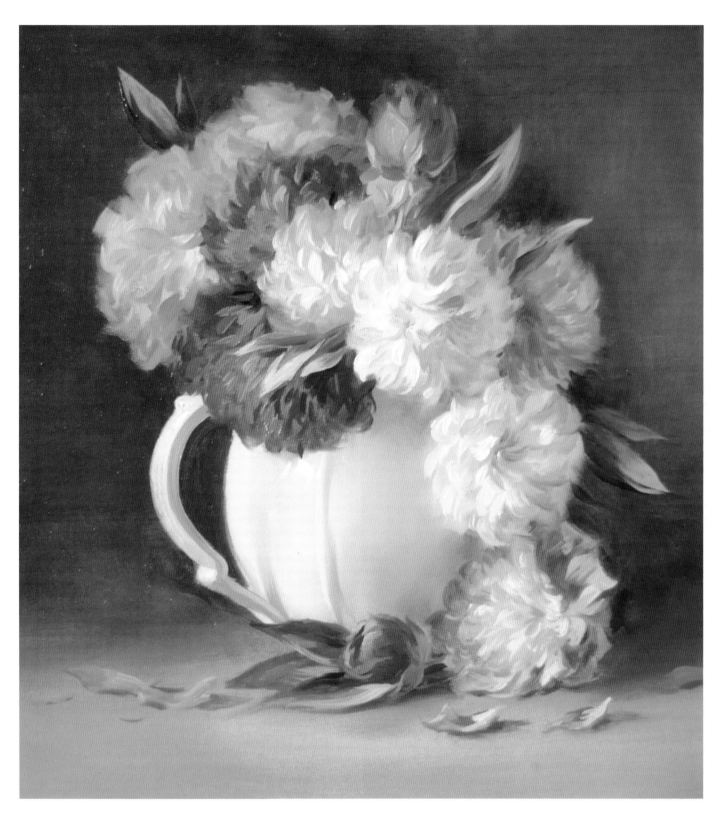

8

White Roses

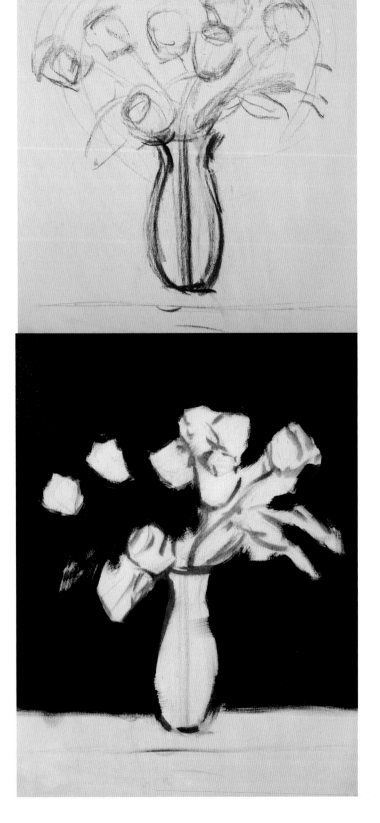

PALETTE

- Titanium white
- Cadmium lemon yellow
- Cadmium yellow light
- Cadmium orange
- Yellow ochre
- Cadmium red light
- Cadmium red medium
- Alizarin crimson
- Cobalt blue
- Ultramarine blue
- Phthalo blue
- Raw umber
- Ivory black
- Phthalo green

Optional colors:
- Burnt sienna
- Magenta

MEDIUM
- one part linseed oil + one part damar varnish + one part English distilled Eurpentine

1

2

1 Sketch the composition with soft vine charcoal. Draw a light horizontal line about two inches from the bottom and begin the composition above the line. For the vase, draw a vertical line in the middle and develop the shape symmetrically on each side.

2 Apply raw umber thinned with oil medium using a #2 bristle brush. Then brush off the charcoal with a large, soft 1-inch brush. Next paint the background with a mixture of ivory black and cadmium red medium.

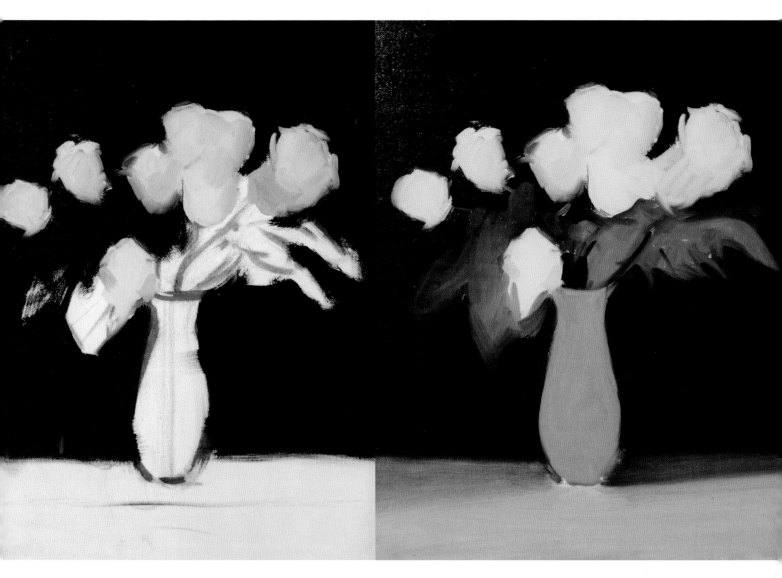

3

4

3 Use a flat color mixture of ivory black and white and a touch of lemon yellow to block in the roses.

4 Next mass in the flat local colors of the leaves, vase, and table—all in their middle tones. The leaves are a mixture of gray and lemon yellow. (Ivory black and lemon yellow also make a nice green for leaves.) The table is yellow ochre in the light and raw umber in the dark, and the vase has a middle tone mixture of gray and yellow ochre.

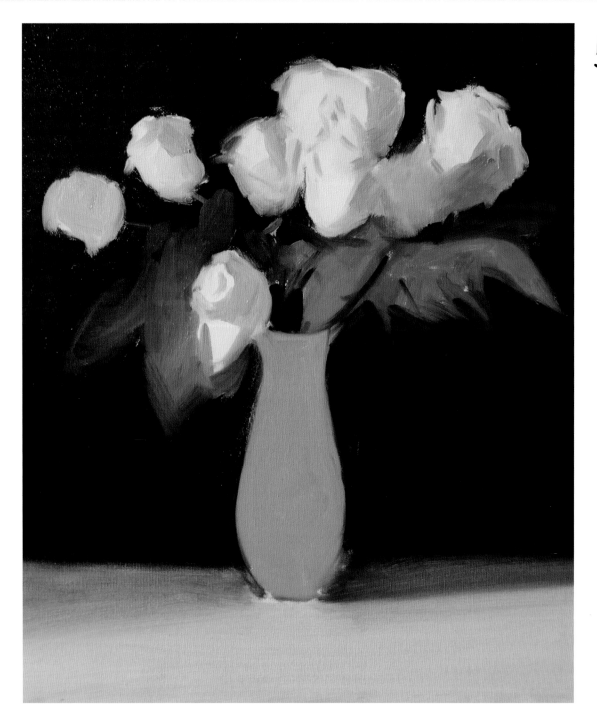

5

5 To give the flowers shape, begin adding shadows to each rose using a mixture of gray and a tiny bit of lemon yellow. Pay attention to the direction of your light source when developing form.

6 Using a #2 bristle brush loaded with titanium white, develop the most illuminated roses on the right side of the composition. Notice how the egg-shaped roses merge into each other, creating lost and found edges.

7 To refine the roses, draw petals around the egg-shaped forms with a #6 round sable brush. Envision the rose petals unfolding in a spiral as you follow the flower's form.

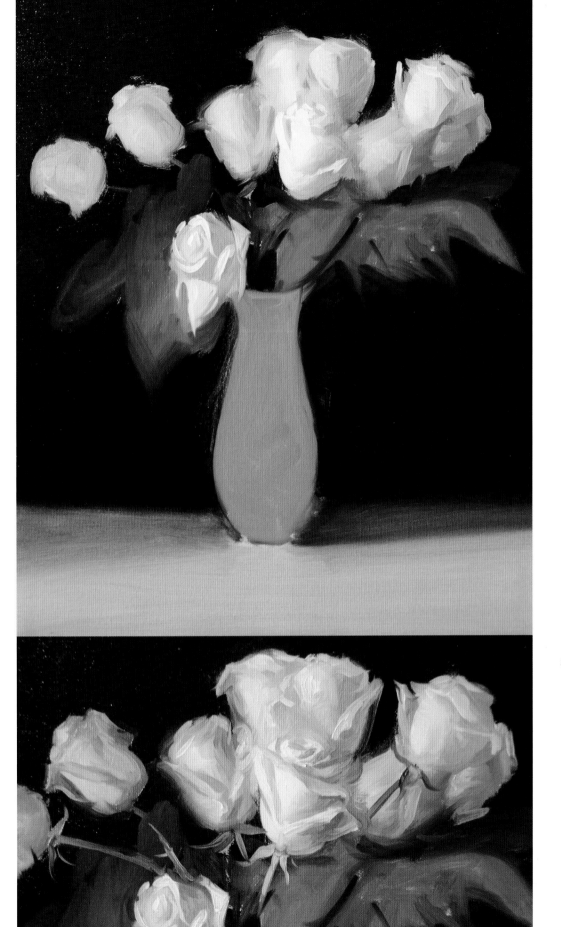

6

7

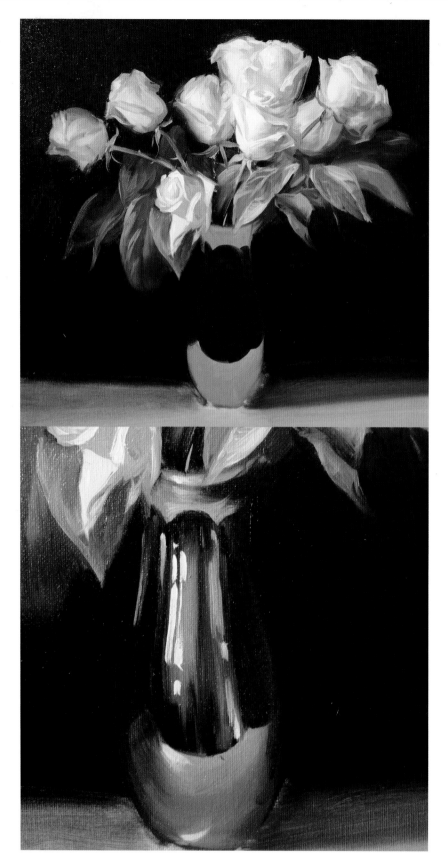

8

Values and colors are cooler and darker as we move away from the light, and warmer and brighter as we move toward the light.

9

8 Mass in the dark of the silver vase with a mixture of alizarin crimson and ultramarine blue. When painting silver or other metallic objects, it's important to note how the edges of such masses are crisp and sharp. Next, develop the light on the leaves with gray highlights.

9 Now finish the vase by observing and painting the lights with lighter gray mixtures of ivory black and white; then adding pure white highlights.

10 After completing the table, make note of any lost and found edges, especially where the vase appears and disappears into the background. The roses on the left of the canvas are cooler and darker as they recede into the shadows.

Painting silver convincingly is all about getting the darks dark enough and the highlights light enough.

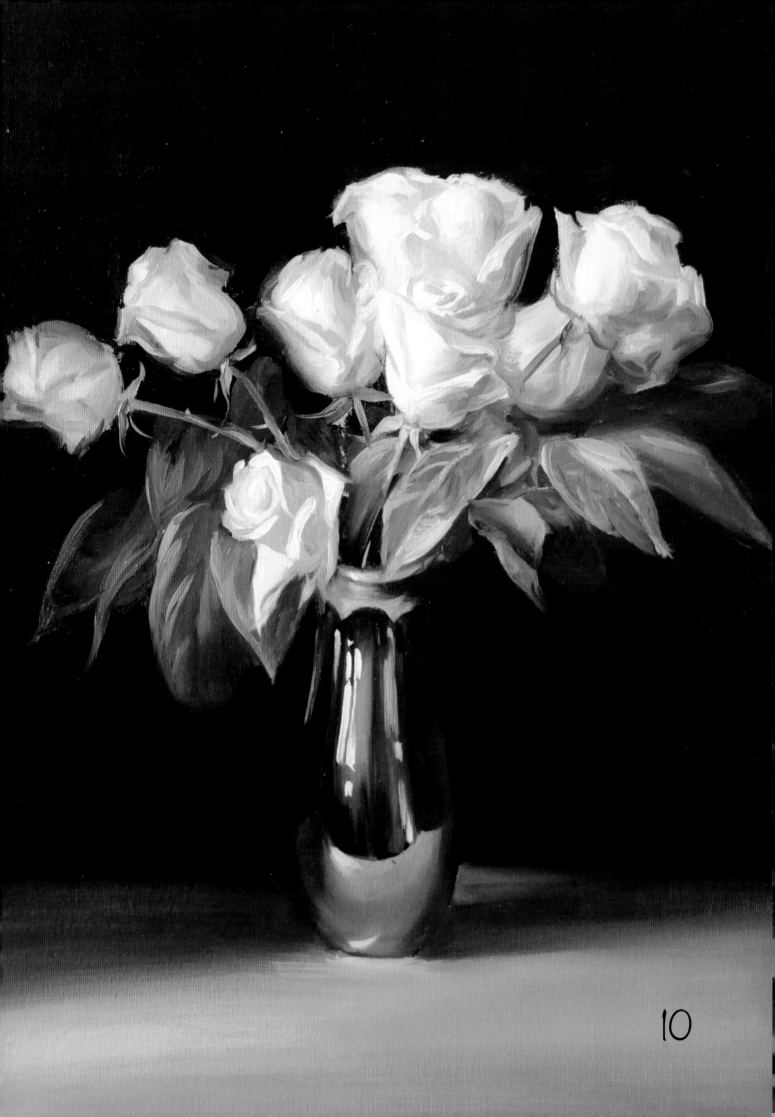

10

Hydrangeas

1

PALETTE

- Titanium white
- Cadmium lemon yellow
- Cadmium yellow light
- Cadmium orange
- Yellow ochre
- Cadmium red light
- Cadmium red medium
- Alizarin crimson
- Cobalt blue
- Ultramarine blue
- Phthalo blue
- Raw umber
- Ivory black
- Phthalo green

Optional colors:
- Burnt sienna
- Magenta

MEDIUM
- one part linseed oil + one part damar varnish + one part English distilled turpentine

2

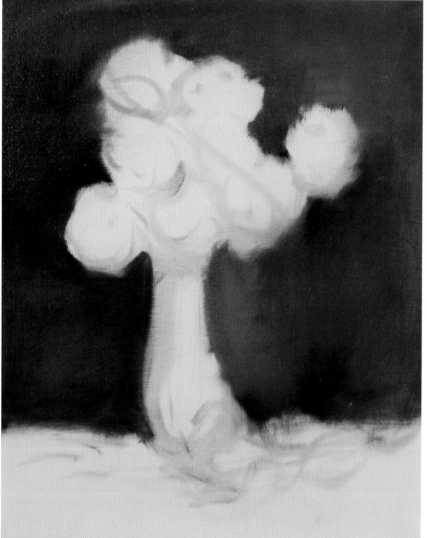

You can always tone a canvas with cadmium red medium or terra rosa thinned with turpentine. The delicate pink color will come through, adding depth and luminosity to the finished painting. You can also use watercolor to tone a canvas.

3

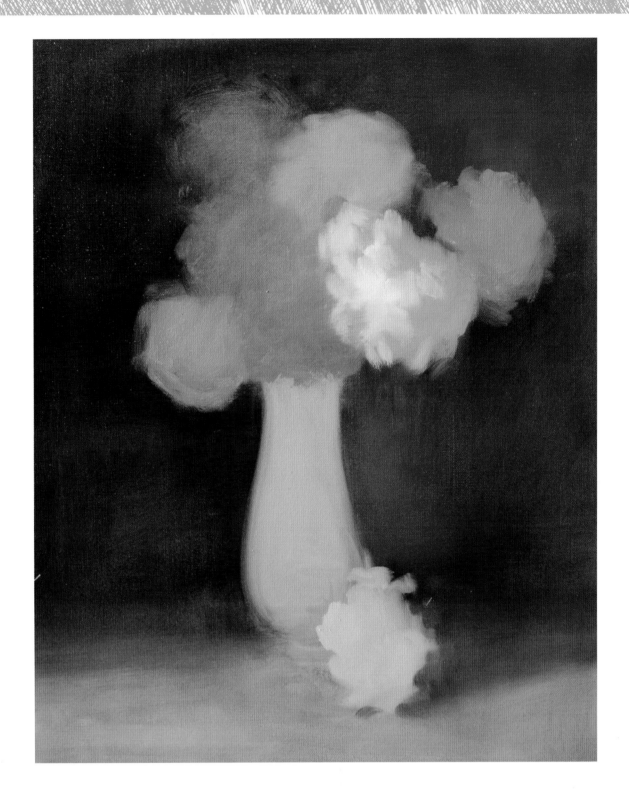

1 Working on a toned 16" x 20" canvas, begin drawing with a #2 white bristle filbert brush loaded with thinned ultramarine blue. Think in terms of the largest forms at this initial stage, keeping in mind that hydrangeas are spherical.

2 Block in the background with a 2-inch white bristle flat brush. Use phthalo green and ivory black for the darker areas, and phthalo green and gray (a mix of ivory black and white) for the lighter areas.

3 Block in the middle values with a mix of cerulean blue, ultramarine blue, and gray for the blue hydrangeas. Use gray for the vase and yellow ochre for the table. For the shadows, mix raw umber with cadmium red light. Block in the white hydrangeas with light gray and a bit of cadmium yellow light.

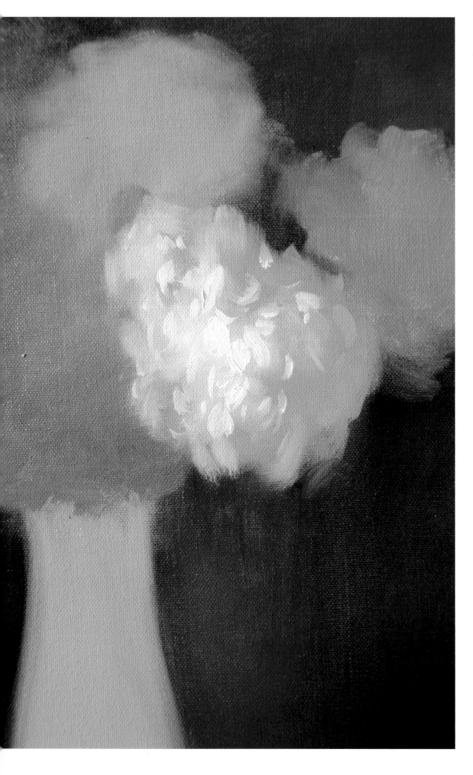

4

When building your lights, load the brush with a lot of paint. Keep the middle tones and darks thinner. This technique will add richness to the final painting.

4 When everything is blocked in, begin working on the light effect and defining the petals. Load a #6 sable brush with a mixture of titanium white and a touch of cadmium yellow light. Then paint each petal individually to suggest the character of the hydrangea.

5 Begin building the lights on the blue hydrangeas as they relate to the white one, which is the focal point of the painting. Use a #6 sable brush to pull out the petals from the mass of each flower. The lights are achieved with a mixture of cerulean blue, ultramarine blue, and titanium white.

6 Add the darker values to the blue hydrangeas with a mixture of ultramarine blue and gray, continuing to build the spherical shapes of each flower. Next use a darker gray for the shadow on the vase, and then add some leaves that contribute to the rhythm of the composition.

5

6

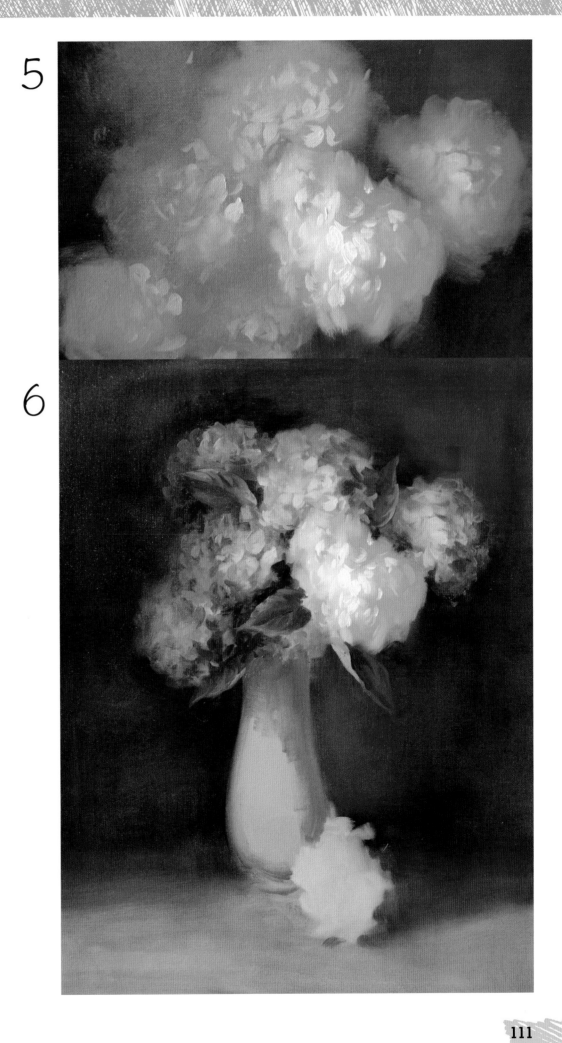

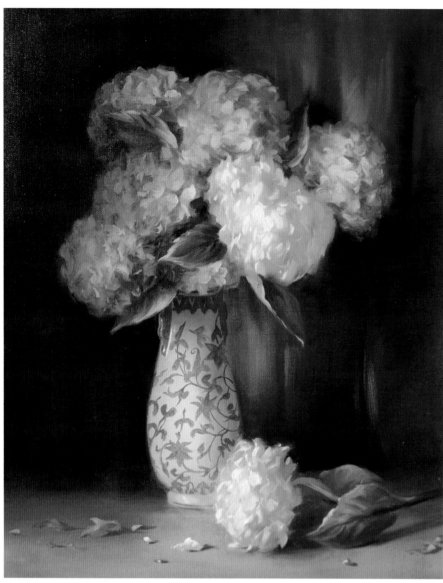

7

7 To create more dimension, add some reflected lights on the flowers. Then use ultramarine blue to paint the design on the vase. For the table, use grays to add more half tones that create a transition between warm light and warm shadow. Paint a few loose petals on the table. Note that the white petals are in the brightest light.

8 For the final touch on the vase, glaze a thin shadow with Payne's gray and add the white highlights. This completes the porcelain texture.

DETAIL This close-up shows the modeling of the flowers. Think of them as out of focus when you begin, and sharper, with more detail, as you develop them. Remember to start in the middle and build your lights and darks.

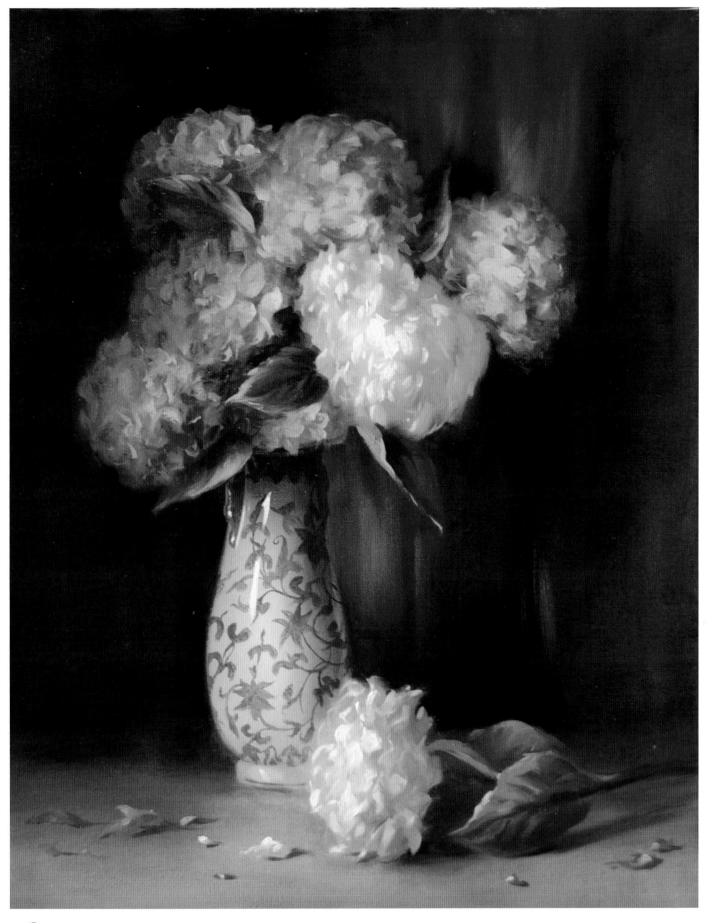

8

Lilacs

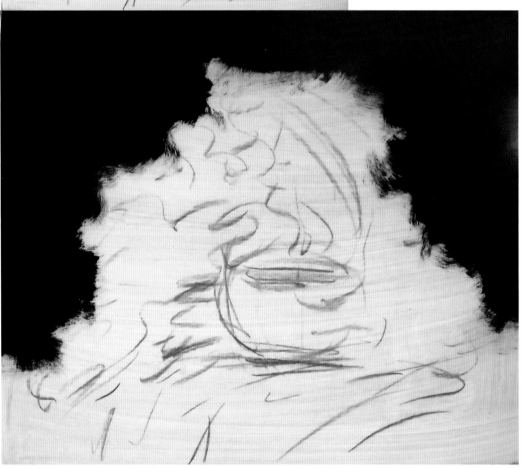

1 Tone a gessoed panel with pink by wiping a mix of cadmium red medium (or terra rosa) and turpentine across the surface with a soft cloth. For a quicker drying time, you can use watercolor paint for this step. Once dry, use soft vine charcoal to sketch the subject with loose, gestural marks that indicate the position of the objects and suggest the flow of the composition. Always try to create compositions that feature a sense of movement, or "dynamic action."

2 Create a dark green mixture of phthalo green, ivory black, and cadmium lemon yellow. Using a 1- to 2-inch flat bristle brush, apply this mixture on the far left background, adding white as you move to the right toward the lighter areas.

3

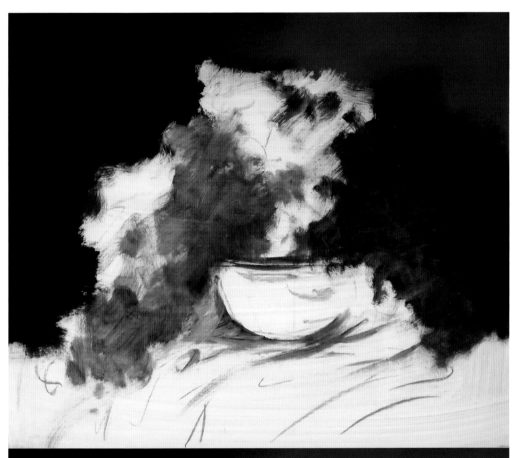

4

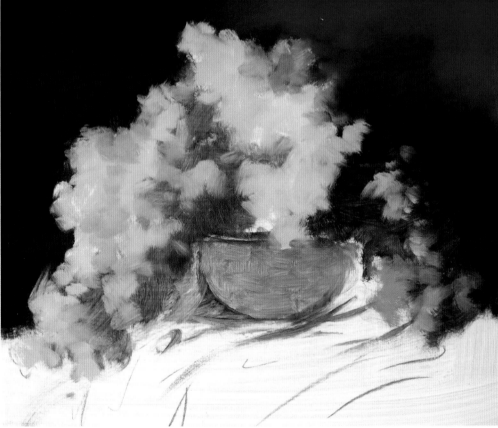

3 Block in the shadows of the lilacs with filbert bristle brushes and dark violet mixtures of alizarin crimson, ultramarine blue, and titanium white. Allow for variation within the masses of color, reserving the cooler, darker tones for the shadowed area at right. Stroke a few warm shadows on the pot and tablecloth using yellow ochre darkened with ultramarine blue.

4 Block in the light masses of the flowers using a lighter value of the violet mixture from step 3, adding more white as needed. Continue blocking in the brass bowl with a mixture of yellow ochre and ultramarine blue.

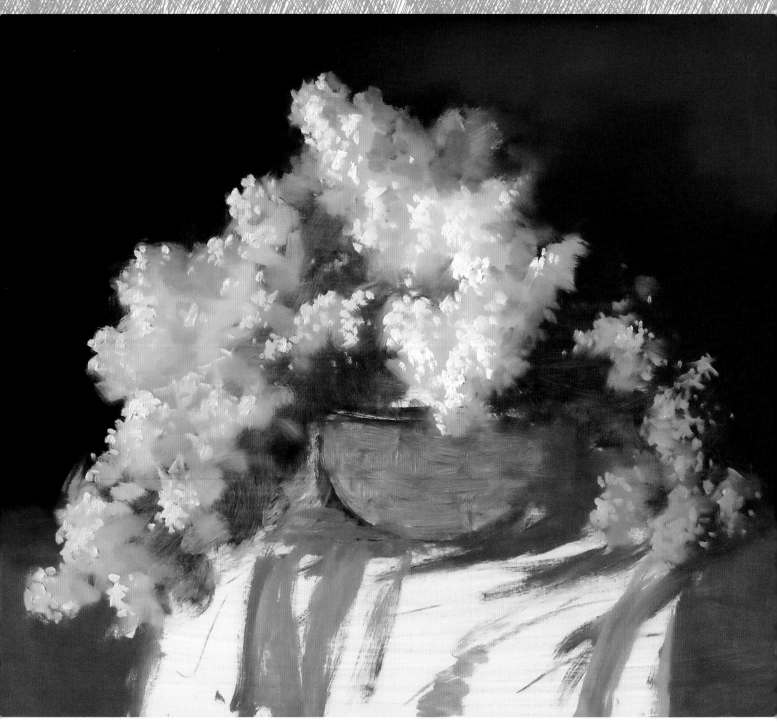

5

FLOWER MASS DETAIL

As you mass in areas of a painting, use large brushes and keep your strokes loose and energetic. Notice the difference in opacity between the deep, transparent shadows and the opaque lights, which communicates depth even in this early stage.

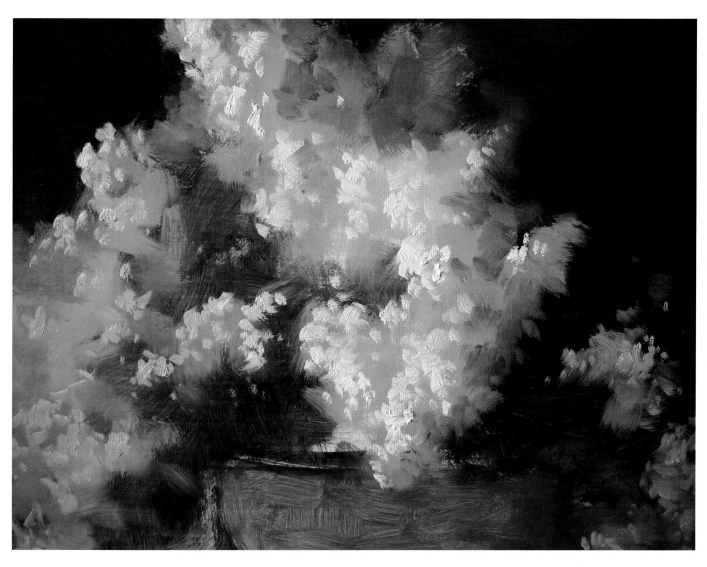

6

5 Block in the darkest shadows of the tablecloth with gray, using a mix of titanium white and ivory black. Then create a green mix of ultramarine blue and lemon yellow toned down with gray and apply it to the green tablecloth. Next, return to the flowers and build the lightest values, using ultramarine blue, alizarin crimson, and plenty of titanium white.

6 Further develop the texture of the flowers, following the rhythm and shapes of the petals using a small filbert brush loaded with paint.

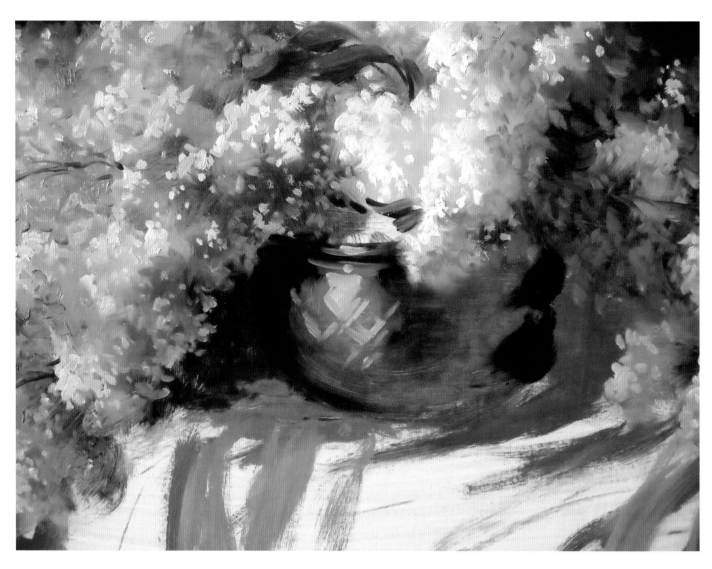

7

7 Begin working on the brass bowl by establishing the darks with a mixture of ultramarine blue and alizarin crimson. Paint the design of the bowl with a mixture of yellow ochre, cadmium yellow medium, and white.

8 Continue to develop the details with a round Kolinsky sable brush. Paint the tablecloth with grays, building up the light to pure white. Then paint the texture of the rest of the lilacs. Notice the reflected light coming from the right as it hits the flowers and the bowl. For these areas, use yellow ochre.

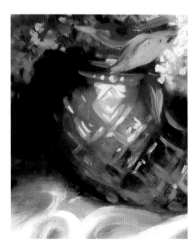

BRASS DETAIL For a more luminous painting, keep the darks transparent and build the lights with opaque layers of paint. Make each stroke count by following the form as you pull the brush.

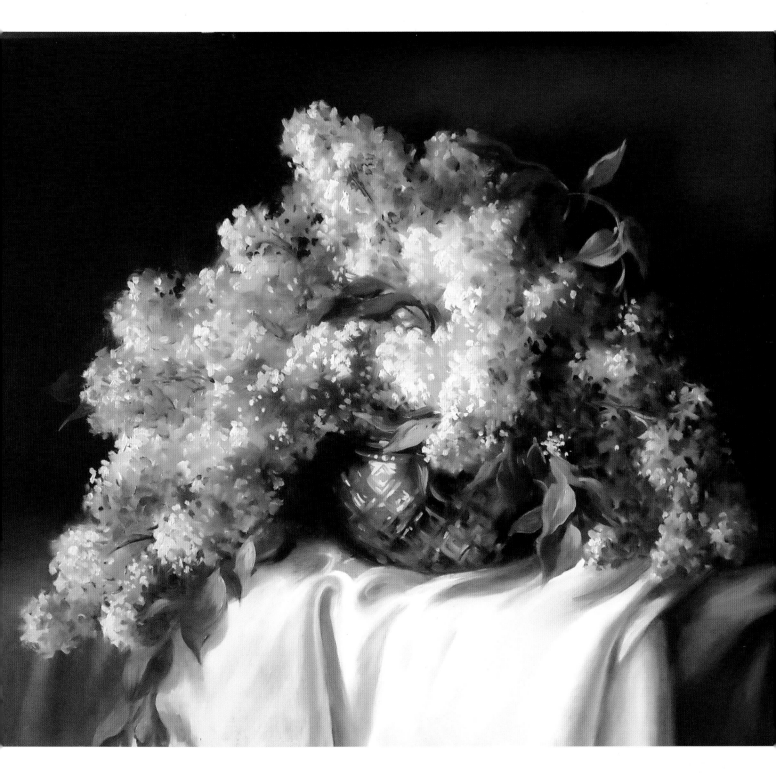

8

CHAPTER 6
WATERCOLOR

Tulips

PALETTE

- Cerulean blue
- Lemon yellow
- Quinacridone rose
- Phthalo blue

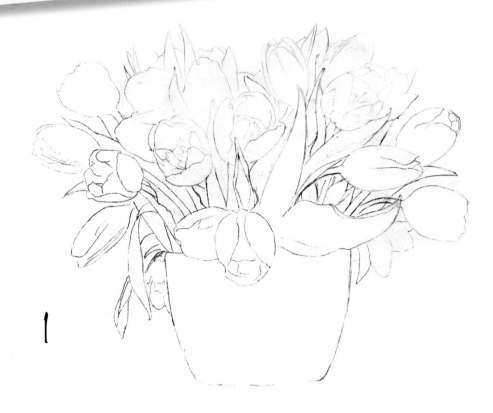

1

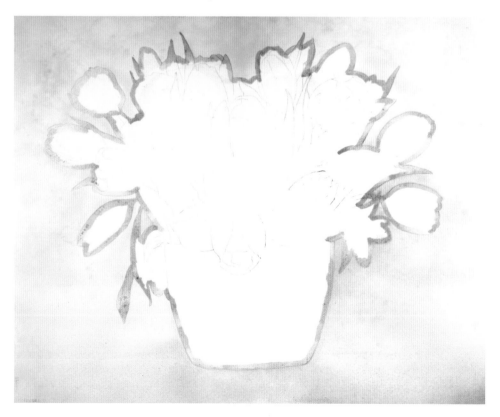

2

1 Create a loose line drawing of the composition.

2 Paint masking fluid around the outer edges before wetting the entire background. Then drop in diluted colors—rose and yellow at the top, rose and cerulean blue on the right, and cerulean blue and yellow at the bottom. Mix the colors, and allow them to blend by tilting the painting. If an area begins to dry, mist it with a spray bottle. Then spatter yellow with a toothbrush.

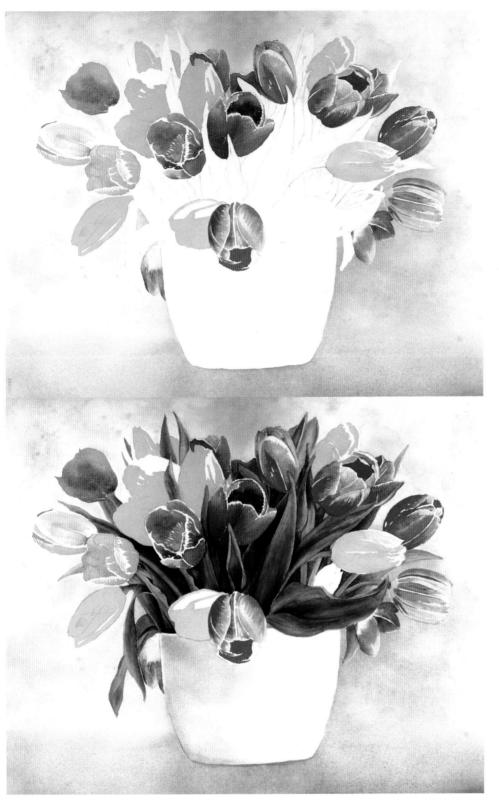

3

4

> Use a palette for mixing
> to avoid contaminating
> your colors.

3 Once dry, peel off the masking and work on the flowers. Keep each color—rose, yellow, and cerulean blue—separate, and use only clean water. Apply a light wash of color.

4 Wet the entire vase with clean water, drop in cerulean blue and a purple mixture on the left side, and tilt the painting to blend. After the vase area is dry, use a light green wash made from both the blues and yellow to cover the leaves. Mixing phthalo blue, yellow, and a bit of rose in varying proportions will create every shade of green needed for the leaves. Beginning with the shadowed areas, paint one leaf at a time. Work on dry paper, and paint the shadows with graded washes to achieve soft dark-to-light transitions.

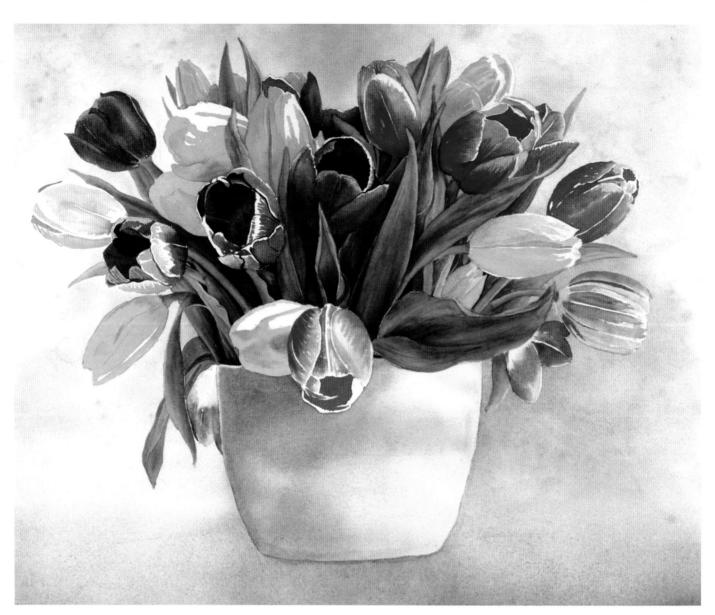

5

Eliminate hard edges on flowers and leaves by rewetting the hard edge with the tip of a small brush and then dabbing it with a paper towel to soften.

5 Give the vase another wash of cerulean blue and purple, again working wet-into-wet. Now finish the flowers. Work the values so that light flower edges are against dark leaves and dark flower edges are against light colors to create maximum visual impact. Keep your colors bright and pure by layering shadow colors and never mixing more than two primary colors at a time. For example, layer yellow tulip shadows with light washes of rose and yellow (orange), rose and cerulean (purple), or yellow and cerulean (green).

6 Wet the vase again before dropping in a final layer of blue and purple. Once dry, paint a small shadow under the edge (darker on the left side) so the vase doesn't appear to be floating. Use white ink to clean up ragged edges and add tiny highlights to a few leaf and flower edges.

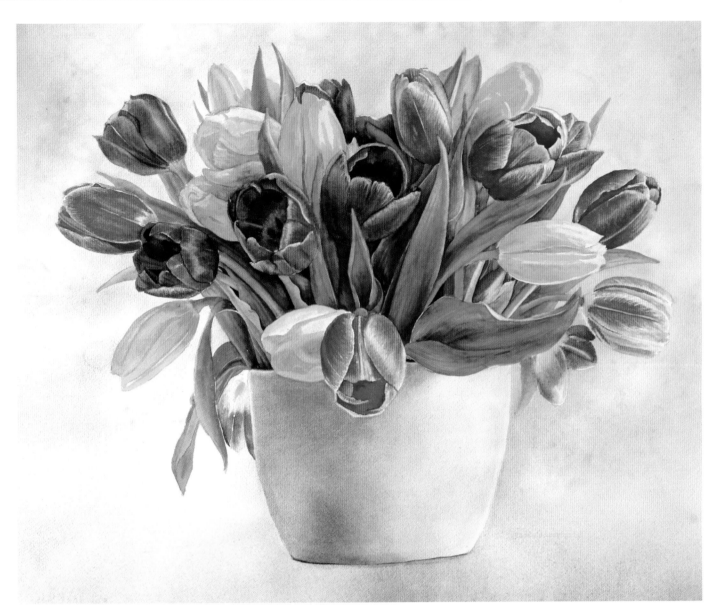

6

GRADATED WASH A gradated (or graduated) wash moves slowly from dark to light. Apply a strong wash of color and stroke in horizontal bands as you move away, adding water to successive strokes.

Flower Field

1

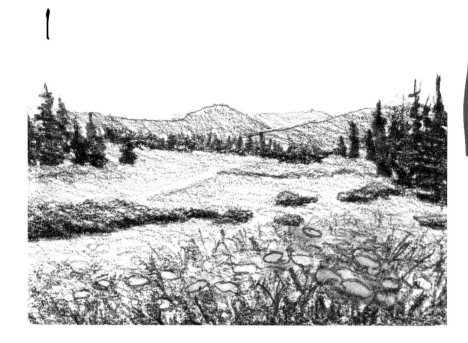

PALETTE

- Burnt sienna
- Hansa yellow
- Lemon yellow
- Raw sienna
- Sap green
- Phthalo blue
- Ultramarine blue
- Yellow ochre

2

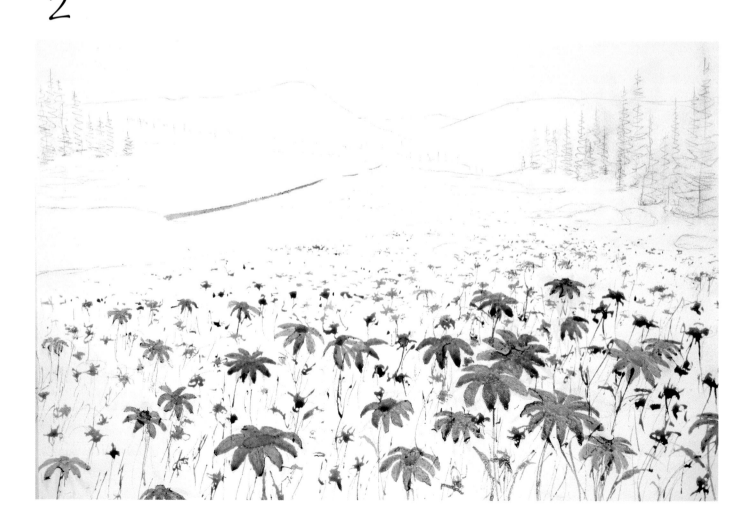

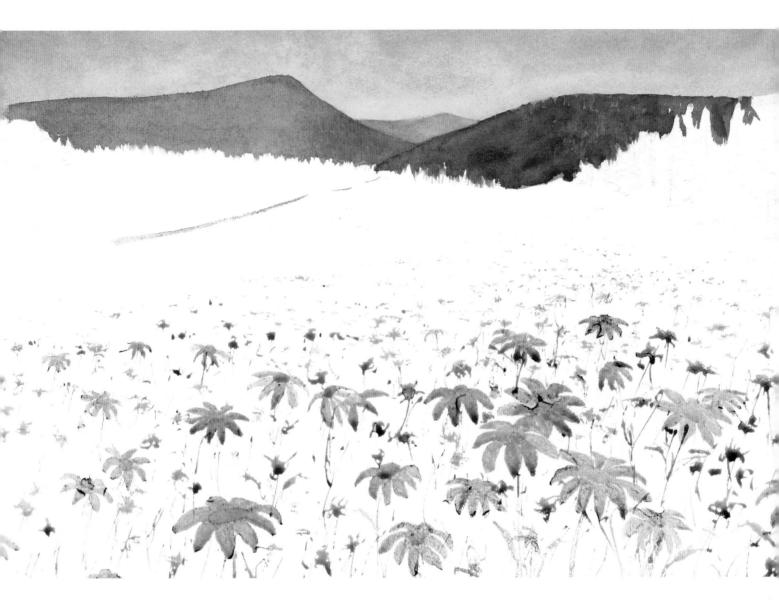

3

1 Make a thumbnail sketch, if desired, to determine the values and composition.

2 Make a line drawing on paper; then mask in the flowers, adding a few extras where it seems natural. Add a little bit of masking to the road in the distance.

3 Wet the sky area with clear water first. Then use a mixture of ultramarine blue, a tiny bit of thalo blue, and a touch of burnt sienna to make a flat wash for the sky, keeping it slightly lighter near the horizon and darker near the top. Next work on the hills from light to dark, using varying mixtures of ultramarine blue, burnt sienna, sap green, and a touch of phthalo blue. On the foreground hill, use a little more sap green and a touch of raw sienna.

Use a little burnt sienna to add warmth to the sky. Pure blue out of the tube looks fake or garish. The sky is generally a darker cool ultramarine blue at the top, changing to a phthalo blue, and then to a warmer and lighter cerulean blue toward the bottom.

4

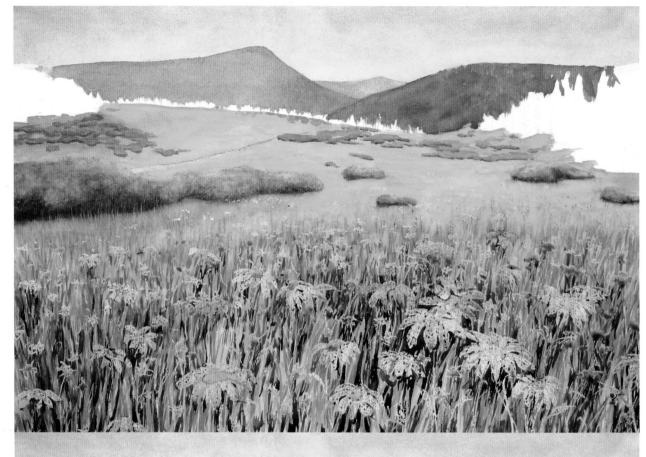

5

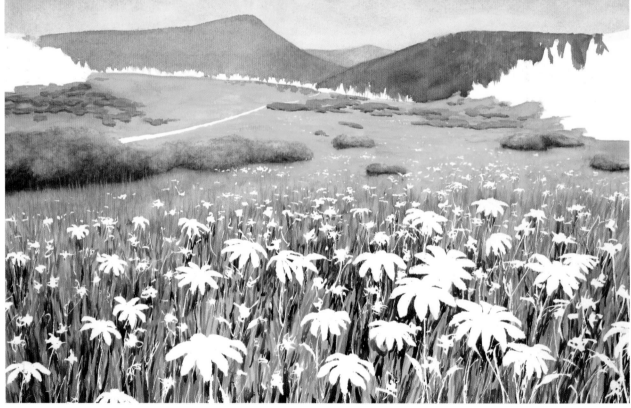

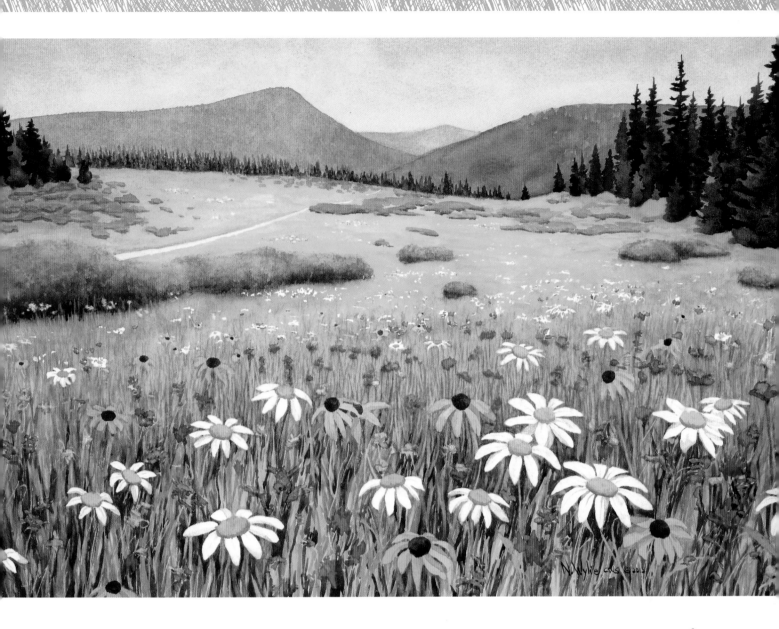

6

4 Mix several puddles of colors before starting to paint. Paint the lightest value with a mix of lemon yellow and ultramarine blue, adding in bits of yellow ochre while it is still wet. Slowly change colors, mixing in darker greens towards the foreground grasses and flower stems, and using different mixtures of ultramarine blue, burnt sienna, phthalo green, sap green, and some hansa yellow. Paint the bushes and flat green areas in the distance; then work in the foreground around the masked flowers, using random back-and-forth motions to create the grasses and stems. Once dry, go back over the grass strokes with a light yellow green. Use a damp brush and soften the edges between the flowers and the transition to the distant meadow.

5 Remove the masking with rubber remover. All the rough edges will be cleaned up when you paint the flowers and stems.

6 Paint the foreground flowers in the colors you wish. Paint the other flowers as abstract suggestions of red, pink, and purple wildflowers. Then paint the trees in the distance. Put a piece of masking tape along the hill edge to keep the dark tree paint from running. Paint the trees, varying the color of green between light and dark. After painting the pines, add drybrush texture to the bushes in front. Then add some glazes of color to the meadow grasses in the distance.

Fall Foliage

PALETTE

- Burnt sienna
- Hooker's green
- Opera
- Permanent green #1
- Permanent orange
- Permanent red
- Permanent
- yellow deep
- Permanent yellow lemon
- Phthalo blue
- Ultramarine blue
- White gouache
- Yellow ochre

3

1 Create a light line drawing of the composition. Use liquid mask to cover the swans until the end of the painting.

2 Mix a light puddle of phthalo blue and a small puddle of opera. After wetting the paper completely, paint a graded wash starting at the top. Pull down a bit of the phthalo blue, keeping it darker at the top and getting lighter as you move down. Mix in a little opera as it approaches the tree line. With a crumpled tissue, blot out a few clouds. On the bottom of the paper, make a mirror image wash of the sky on the water area. The wash should start light and grow stronger as it nears the bottom of the paper.

3 Use all the colors in your palette to create the colorful fall foliage. Work on dry paper so you can define the edges of your foliage. Use a 1/2″ flat brush to form a foundation at the lake edge and a natural sea sponge to create leafy texture at the tops of the trees. As you chase the wet edge across the page, analyze the pattern of trees being created for interest, balance, color, and randomness. Don't go back over any area that is starting to dry as this will muddy the colors.

4

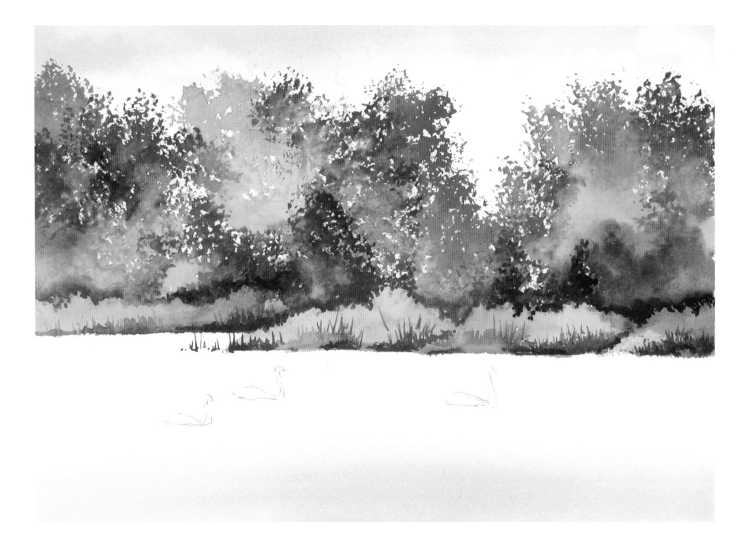

4 Once the colorful wash is completely dry, separate the low plants and reeds at the bottom of the foliage. Using a medium round brush, drop in stronger and darker colors at the top of this section, using negative painting around the reeds to shape them. Stipple and vary the edge up and down to form an interesting edge. With the 1/2" flat brush and a small amount of water, feather the wet, stippled paint up into the first colorful wash. When stippling, be careful to place analogous colors on top of existing colors to avoid muddiness. Create additional detail and shadows at the bottom edge where the reeds meet the water for interest and definition.

5

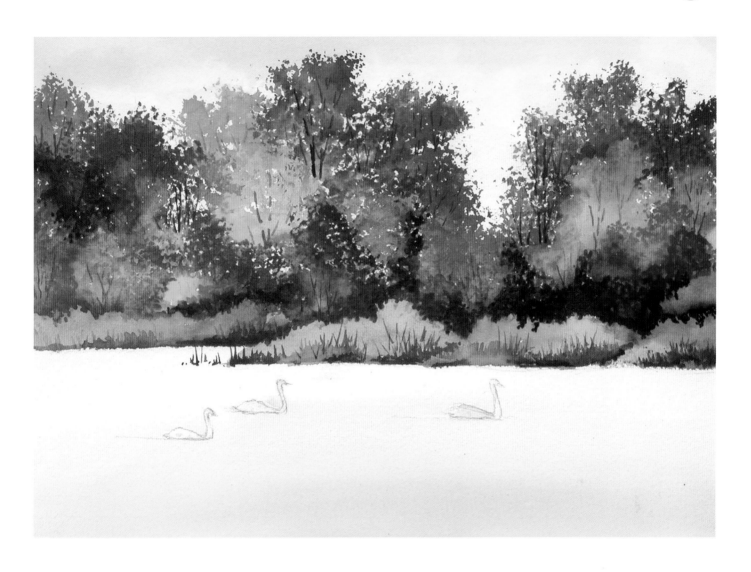

5 Next add definition to the trees. Pick areas suggested by the colorful wash and create bits and pieces of tree edges. Add stronger color around the tree edges, leaving the existing color in place, to create dimension. Remember that this is a cluster of trees and you are only painting parts of trees rather than perfect rows. Once you have an interesting cluster of trees, add a few trunks and branches using a rigger brush.

6

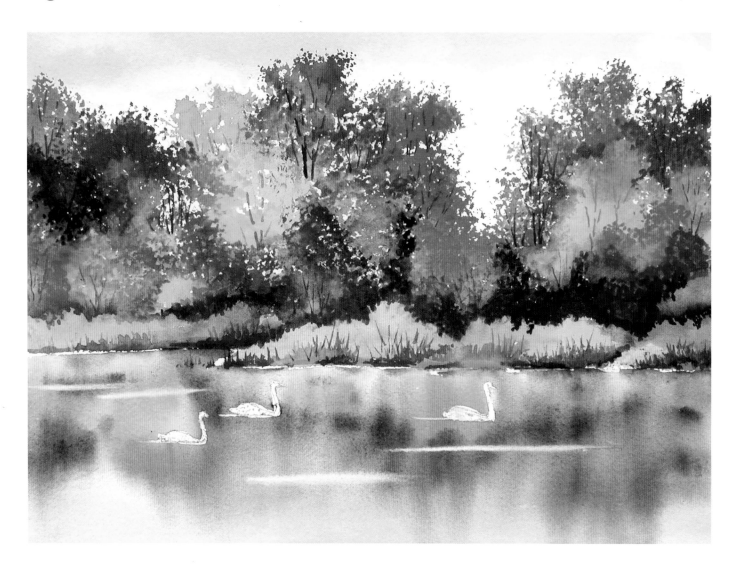

6 Make sure all the tree color paints are wet on the palette so you can work quickly in this step. With a flat brush, wet the entire water area of the painting. Then, with the 1/2-inch flat brush, pick up colors and add them in the water area below those same colors in the trees. Keep these colors close to the shore. The colors do not need to exactly match to the trees above, but should be close. Once the color is applied, take a damp 1" flat synthetic bristle brush with no paint in it and pull a vertical stroke from the shoreline down to the bottom of the page. Clean the brush, squeeze the moisture out with a tissue, and repeat several times until you have a soft, slightly blurred reflection across the entire lake. While the water is wet, lift a few horizontal strokes out with a clean,

damp synthetic bristle brush to create soft ripples in the water.

7 Once the lake is dry, remove the mask from the swans and paint them. With a small detail brush, paint a little shadowing on their necks and lower bodies. Paint the beaks and eyes, as well as stronger shading where the swans meet the water to make them appear to be swimming. The swans are white and should remain a light value so they stand out from the color in the water. If you did a good masking job initially, very little detail is needed. Add swan reflections with white gouache.

7

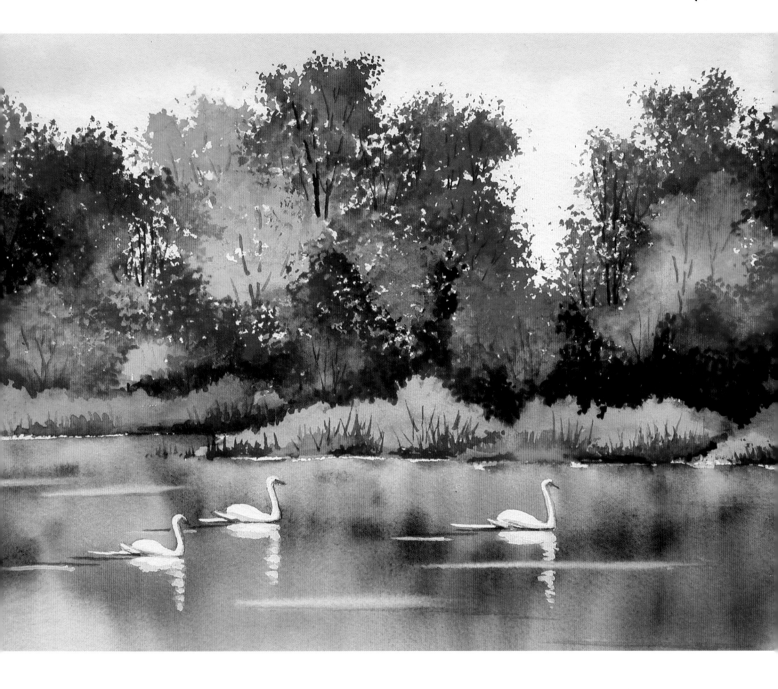

Summer Garden

1

PALETTE

- Ultramarine blue
- Hooker's green
- Permanent green #1
- Permanent green #2
- Permanent lemon yellow
- Permanent yellow deep
- Permanent magenta
- Opera
- Permanent red
- Lilac
- Phthalo blue

2

1 Roughly sketch out the composition; then mask the white flowers with liquid frisket.

2 Block in the flower color using permanent red, permanent lemon yellow, permanent yellow deep, lilac, and opera. Block in a hint of green foliage for the plants with permanent green #1.

3 Mask some of the flowers you just painted. The mask dries transparent, which lets you see both the color and the value of that color under the mask as the painting develops. Mask out some of the plant shapes and edges, particularly at the bottom and side areas of the fence, using a small brush and a sea sponge.

4

5

4 Next wet the entire watercolor paper and flood in some of the cool colors in the background, around the edges, and a few shadows cast across the fence. Use phthalo blue, opera, magenta, and permanent green #2. Try to keep these colors away from the center areas or sections where you want bright, lively colors. Once the colorful wash is dry, carefully mask out the picket fence, including the slats, cross rails, and corner post.

5 When the mask is completely dry, rewet the paper and flood in Hooker's green, ultramarine blue, phthalo blue, permanent green #2, and magenta for the darker value colors. Use both a 1" flat brush and a sea sponge to create plant leaf texture. Stamping in with the sea sponge while the paper is wet creates softer-edged texture for more variety.

6

Remember that "what you mask is what you get." Take time with your masking and work carefully so that when you remove your mask, you have a neat, white fence.

6 Dry the painting completely with a hair dryer, and then remove all the masks with a masking fluid pickup. Before removing the mask make sure both the masking fluid and the wash are completely dry. If the mask is still damp underneath, it can tear the paper. If the paints are still slightly damp, they will bleed into the areas you protected with the mask. With the mask removed, you can see your painting coming alive. The picket fence stands out against the darker background and the colorful splash of flowers is apparent.

7 Add more color to the flowers, including detail to the roses and irises. Enhance the garden scene using a medium round detail brush, as well as a rigger brush and a sea sponge for leafy texture. Plant foliage, shadowing, and additional random areas of colors help to fill out the garden.

8 Adjust plant shapes and flower colors for a sense of realism and balance in the painting, adding color as needed with a small brush. To give the painting more depth and variety, knock back some of the flowers into shadows, particularly at the corners and some of the bottom of the garden. Use a 1" flat brush and phthalo blue mixed with opera to create shadows. For a final touch, enhance the shadows cast across the picket fence, creating a more dramatic sense of light and shadow.

7